THOMAS MERTON'S
Gethsemani

"I have not written what a paradise this place is, on purpose.
I think it is more beautiful than any place I ever went to for its
beauty—anyway, it is the most beautiful place in America. I never
saw anything like the country. A very wide valley—full of rolling
and dipping land, woods, cedars, dark green fields—maybe young
wheat. The monastery barns—vineyards."

(*Run to the Mountain*, April 10, 1941)

LANDSCAPES

Introduction by JONATHAN MONTALDO
Foreword by BROTHER PATRICK HART, OCSO

THE UNIVERSITY

THOMAS MERTON'S

Gethsemani

OF PARADISE

Photographs by HARRY L. HINKLE

Essay by MONICA WEIS, SSJ

PRESS OF KENTUCKY

Publication of this volume was made possible in part by a grant from
the National Endowment for the Humanities.

Scholarly publisher for the Commonwealth, serving Bellarmine University,
Berea College, Centre College of Kentucky, Eastern Kentucky University,
The Filson Historical Society, Georgetown College, Kentucky Historical Society,
Kentucky State University, Morehead State University, Murray State University,
Northern Kentucky University, Transylvania University, University of Kentucky,
University of Louisville, and Western Kentucky University.
All rights reserved.

Editorial and Sales Offices: The University Press of Kentucky
663 South Limestone Street, Lexington, Kentucky 40508-4008
www.kentuckypress.com

Interior design and composition by Stephanie Foley

Frontispiece: THE ABBEY CHURCH AT OUR LADY OF GETHSEMANI, TRAPPIST, KENTUCKY *Photo* #MF67-08

09 08 07 06 05 5 4 3 2 1

Library of Congress Cataloging–in–Publication Data

Weis, Monica, 1942–
 Thomas Merton's Gethsemani : landscapes of paradise / photographs by Harry L.
Hinkle ; essay by Monica Weis ; introduction by Jonathan Montaldo ; foreword by Patrick
Hart.
 p. cm.
Includes bibliographical references.
 ISBN 0–8131–2348–8 (alk. paper)
 1. Merton, Thomas, 1915–1968—Homes and haunts—Kentucky. 2. Abbey of Our Lady
of Gethsemani (Trappist, Ky.)—Pictorial works. I. Title.
 BX4705.M542W45 2005
 271'.1250769495—dc22
 2004027051

Manufactured in South Korea

 Member of the Association of American University Presses

CONTENTS

FOREWORD Brother Patrick Hart vii

A NOTE ON THE PHOTOGRAPHS Harry L. Hinkle xi

LIST OF ABBREVIATIONS xv

INTRODUCTION *The Landscape of His Divinely Appointed Place* 1
Jonathan Montaldo

CHAPTER 1 *Discovering the Earthly Paradise* 17

CHAPTER 2 *Finding a Home in Nature* 37

CHAPTER 3 *Seeing Paradise with the Heart* 73

CHAPTER 4 *Becoming One with the Sky through Prayer* 113

CHAPTER 5 *Discovering Compassion in the Wilderness* 135

NOTES 149

PERMISSIONS 155

FOREWORD

IN RECENT YEARS, when the abbot or one of the monks of Gethsemani would be introduced to His Holiness, Pope John Paul II, the latter usually responded, "Oh, Gethsemani, that is Thomas Merton's monastery." The abbot or monk would hesitatingly agree that, after a manner of speaking, Gethsemani *was* Thomas Merton's monastic home. It might be more accurate to say that the young, orphaned Tom Merton found his first real home at Gethsemani. The title of this handsome volume unambiguously reflects the reality that Merton found Gethsemani an earthly paradise, situated as it was in the midst of the knob country of Nelson County in central Kentucky.

The wonderful thing about *Thomas Merton's Gethsemani* is that it brings together a very gifted trio in the persons of Harry Hinkle, Jonathan Montaldo, and Monica Weis. The latter's engaging essay essentially relies on Merton's best writings on nature, drawn mainly from his journals, from the time he entered Gethsemani in 1941 until his last days in the hermitage in the summer of 1968. Harry Hinkle's splendid photographs, so reminiscent of Merton's own photography, complement the text in a way Merton would surely have approved of. Added to this is Jonathan Montaldo's insightful introduction, which sets the tone for an authentic experience of walking in the steps of Father Louis—as Merton was known in the monastery—and enjoying the landscapes as Merton did himself during the twenty-seven years he spent on this part of the planet.

Taken as a whole, this volume evokes in the reader a sense of accompanying Merton in his solitary hikes in the woods, or joining him in his quiet early-morning meditations on the porch of the hermitage while looking east toward the rising sun. Here, facing his neighbors at Loretto, a shy, wild deer would occasionally venture from the nearby woods and startle him with its beauty.

Other writers and artists have attempted similar feats in an effort to capture something of Merton's trajectory. Paul Wilkes's film biography retraces Merton's steps from his birthplace in Prades, France, at the foothills

of the Pyrenees, to Douglaston, New York; then on to England, to Merton's early schools at Oakham and Cambridge; returning to New York, where he continued his studies at Columbia University, writing his master's thesis on "Nature and Art in William Blake." From here Merton traveled to Olean, New York, where he taught at Saint Bonaventure College for several years before entering Gethsemani on December 10, 1941.

A movement has begun during the past decade to arrange pilgrimages to places in New York's Greenwich Village, Columbia University, Corpus Christi, as well as to his birthplace and the sites of his early schooling in southern France. More recently pilgrimages have been undertaken to the Far East in order to trace Merton's last days, ending with Bangkok and the Red Cross location where he accidentally touched a faulty standing fan, which brought him back to his home at Gethsemani, and ultimately to his true home in the eternal paradise.

Some years before his death, James Laughlin—Merton's friend and editor at the New Directions publishing company in New York and one of the original trustees of the Merton Legacy Trust, which supervised the contracts for Merton's writings—conceived the idea of publishing a volume of Merton's writings on nature much like the present one. He also proposed a book on Merton's selected writings on the Far East, such as Zen Buddhism and Hinduism. The latter won out and was brought out as a bibelot by New Directions titled *Thoughts from the East*. After Laughlin's death, I thought the idea of bringing out a volume of Merton's writings on nature had been abandoned forever. However, in addition to Kathleen Deignan's *When the Trees Say Nothing: Thomas Merton's Writings on Nature*, I believe that *Thomas Merton's Gethsemani* fulfills that desire and would please Laughlin and Merton as much as it pleases me.

In his last letter to me from Bangkok dated December 8, 1968 (the Feast of the Immaculate Conception), just two days before his tragic death, Father Louis wrote: "I think of you all on this Feast Day and with Christmas approaching I feel homesick for Gethsemani. I hope to be at least in a monastery—Rawa Seneng (in Indonesia). Also, I look forward to being at our monastery at Hong Kong, and may be seeing our three volunteers there. . . . No more for the moment. Best love to all, Louie."

Ironically, he returned to his "old Kentucky home" by way of a military plane carrying American soldiers who had lost their lives in Vietnam. He lies buried under a small cedar tree at the place he once called paradise. A simple white cross marks his grave, which is no different from his brothers who preceded him in death and is now surrounded by more recent arrivals. May we all meet at our eternal paradisiacal home and join Thomas Merton where the peace he sought all his life will become a permanent reality.

For the present, this volume may be the closest we will come to experiencing that peace, and for this we must be grateful to Harry Hinkle, Jonathan Montaldo, and Monica Weis—as well as to the University Press of Kentucky—for producing such a precious gift. It should find a home in the library of all who treasure the writings of Thomas Merton and his Christian witness as a monk of Gethsemani.

Brother Patrick Hart, OCSO

A NOTE ON THE PHOTOGRAPHS

ON A FINE OCTOBER MORNING, as I stood looking at a reflection of pine trees in the unruffled waters of Dom Frederic's Lake, across Monks Road from the abbey, I immediately felt drawn to this wonderful place where Thomas Merton lived for nearly three decades. It had been many years since I first visited Gethsemani, nestled in the knobs of Nelson County, Kentucky, yet it somehow felt familiar.

In my twenty-two years of photographing, I have learned that I prefer to do my work away from noise and other distractions, instead seeking quiet places among woods, hills, lakes, streams, and fields. I avoid crowds of people, traffic, and other man-made clamor that often overwhelms our senses. At Gethsemani I was sheltered from the barrage of noise that is so much a part of our society. Still, my work was at first rushed. I kept close tabs on the time; walked hurriedly through the woods; worried about whether I had brought the right lenses and film; and thought about how long it would take to drive home. I wasn't relaxing enough to *enjoy* the process.

Eventually that changed. As I read more of Merton's essays, poetry, and journals, and as I made additional visits to Gethsemani, I noticed that I was working more methodically and patiently. As I learned the lay of the land— the names of the knobs and lakes, where the sun rose and set in all seasons— it became clear that the peace of this place was getting into my bones, and I liked how that felt.

I had also recently visited the Thomas Merton Center at Bellarmine University, where I discovered (after realizing that I had never seen any of Merton's own photographs) that there were strong similarities in our choice of subject matter. Among the objects and scenes he had photographed at Gethsemani were barns, buckets, benches, weeds, views of the hills, tree stumps and tree limbs, wagon wheels, fields and fence posts, saw-horses, and firewood. He had found and focused on very ordinary objects, just as I prefer to do in my own photography. However, Merton managed to capture the essence of those objects—he saw God in them—whereas I have not yet learned to do that.

Nevertheless, photographing the geographical landscape presented

some unique rewards and challenges. Whenever possible, I photograph in the soft, flattering light of early morning and early evening. I knew, though, that while Merton had a fondness for clear, sunny skies, he also loved bleak, cloudy, cold, rainy days—not the best kind of weather for photographs or photographers. He felt a sense of solace, peace, and strength in the sometimes gloomy weather at Gethsemani. So I mustered my forces and set out for the woods and hills in some rather raw weather. As it turned out, I got some of my best pictures on these less than "picture-perfect" days.

I stood in bitter cold weather at the top of St. Joseph's Hill to catch a late-winter sunrise and lugged my cameras and tripod up the steep slopes to the tops of Vineyard Knob, McGuinty's Hollow, and Cross Knob. I walked through deep snow to Dom Frederic's Lake, swatted deer flies in the summer heat in the woods beyond St. Malachy's Field, and stood in the rain to photograph puddles and cloudy skies.

On more comfortable days I experienced the freshness of early spring, when the trees begin to bud and the earliest wildflowers bloom. I saw beautiful dawns and sunrises, felt soft summer breezes blowing from the southwest, heard the sweet songs of birds in the fields and woods, and witnessed the gorgeous colors of the woods in the fall.

Although I was becoming more familiar with the physical geography of Gethsemani, I began to realize some of the challenges awaiting me as I attempted to record the built environment of the abbey. I knew I wanted to photograph the many barns, sheds, and other outbuildings inside or near the enclosure wall. After all, Merton has provided such wonderful descriptions of these structures. As I tried to locate and photograph them, however, I quickly discovered how many had disappeared. I can't explain why I thought they would still be there—as if they had been placed in some kind of time capsule—but a half-century of changes had deeply altered that aspect of the landscape.

Sadly, I found that St. Anne's, the little tool shed where Merton would escape for writing and meditation, was close to ruin. Its wooden floor was nearly gone. Time and the elements had taken their toll. Also, for nearly a year and a half I searched for the garden shed—one of Merton's most beloved places at the abbey—with its wonderful attic and window view of the valley. Both that shed and the sheep barn, another of Merton's favorite buildings, have disappeared from the landscape. Moreover, the metal covering from the cross on the old bell tower lay rusting at the top of Cross Knob. Also gone were the altar where Merton took his solemn vows, the gatehouse, the scriptorium where he liked to sit and watch the rain, the distillery, and the train station to the south of the monastery.

Given the fact that so much had changed since Merton had entered

the monastery in 1941, what was left to photograph? I would need to look more closely and carefully at what remained. In this effort I would not be disappointed.

I was moved by the simplicity of the white crosses in the Monks' Cemetery at the side of the church, the tall, gray enclosure wall, and the remnants of the orchard where Merton sat on spring mornings and observed the bees working among the flowers. I saw the morning mist lift slowly from the small valley where he walked to and from the hermitage. I felt the strength and solidity of the Shops Building, with its solid stone walls and overwhelming presence. My hands shook nervously as I photographed the night watchman's clock, the guest register in which Merton had signed his name during his first visit to the abbey, and the ancient Latin books once used for the liturgy of the Office.

On my third attempt to find Edelin's Hollow, that wild and wonderful place south of Gethsemani, near New Hope, I was fortunate to locate the current owner, who gave me permission to explore the long hollow. Though changed since Merton first walked its steep-sided valley, I could see why his love for the wildness of nature would attract him to this place.

Though the photographs did not always come easily, the challenge was among the most gratifying I have ever experienced. I had set out to find and capture—as closely as possible—the wonderful scenes of Gethsemani that Merton had repeatedly depicted in his work. I wanted to understand how and why Thomas Merton loved this landscape. In the end, I think my knowledge and understanding of Merton and the monastery expanded considerably. I am grateful for the opportunity to share these photographs with others. I expect I will return to Gethsemani many times in the future.

Several people were enormously helpful in my efforts to take the photographs for this book. I am indebted to them for taking the time to share their knowledge of Merton and Gethsemani.

First, I want to thank the Gethsemani monks for their kindness and hospitality during my many visits to the abbey. Above all, my appreciation goes to Brother Patrick Hart, OCSO, Thomas Merton's personal secretary and the editor of many books by and about Merton. Brother Patrick made it possible for me to locate and photograph many locations, buildings, and artifacts at the abbey. Despite his very busy schedule, he obliged me time and again.

Second, I wish to thank Brother Alfred McCartney, OCSO, Gethsemani archivist, for his invaluable assistance in locating many of the historic documents, volumes, and other items I photographed for this book.

I am also grateful to Brother Paul Quenon—community cook, poet, photographer, and director of education—who took me to Hanekamp's home and to McGuinty's Hollow, both located in the far reaches of the monastery property. He also showed me the old red trailer once used by Merton as a hermitage and suggested the best places and times to observe and photograph deer.

My thanks also go to Paul M. Pearson, director and archivist of the Thomas Merton Center at Bellarmine University, who made it possible for me to photograph items from the center's archives and to view the contact sheets of Merton's photographs.

My gratitude also extends to Patrick F. O'Connell whose command of Merton's poetry has made this a richer text.

Finally, I am deeply indebted to John "zig" Zeigler, a former editor at the University Press of Kentucky, whose original vision and passion for this book served as a catalyst and driving force during its creation. I owe him eternal thanks for giving me the opportunity to make the photographs for *Thomas Merton's Gethsemani.*

Harry L. Hinkle

ABBREVIATIONS

AJ *The Asian Journal of Thomas Merton.* Ed. Naomi Burton Stone, Patrick Hart, and James Laughlin. New York: New Directions, 1973

CGB *Conjectures of a Guilty Bystander.* New York: Doubleday, 1966

CNP *Contemplative Prayer.* New York: Herder & Herder, 1969

CP *The Collected Poems of Thomas Merton.* New York: New Directions, 1977

DS *Day of a Stranger.* Ed. Robert E. Daggy. Salt Lake City, Utah: Gibbs M. Smith, 1981

DWL *Dancing in the Water of Life: Seeking Peace in the Hermitage.* The Journals of Thomas Merton, vol. 5: 1963–65, ed. Robert E. Daggy. San Francisco: HarperSanFrancisco, 1997

ES *Entering the Silence: Becoming a Monk and Writer.* The Journals of Thomas Merton, vol. 2: 1941–52, ed. Jonathan Montaldo. San Francisco: HarperSanFrancisco, 1996

IE *The Inner Experience: Notes on Contemplation.* Ed. William H. Shannon. San Francisco: HarperSanFrancisco, 2003

LL *Learning to Love: Exploring Solitude and Freedom,* The Journals of Thomas Merton, vol. 6: 1966–67, ed. Christine M. Bochen. San Francisco: HarperSanFrancisco, 1997

MJ *The Monastic Journey.* Ed. Patrick Hart. Kansas City, Mo.: Sheed Andrews and McMeel, 1977

MP *Monks Pond: Thomas Merton's Little Magazine.* Lexington: University Press of Kentucky, 1989

NMII *No Man Is an Island.* New York: Harcourt Brace, 1955

NS *New Seeds of Contemplation.* New York: New Directions, 1962

OSM *The Other Side of the Mountain: The End of the Journey.* The Journals of Thomas Merton, vol 7: 1967–68, ed. Patrick Hart. San Francisco: HarperSanFrancisco, 1998

PAJ *Thomas Merton: Preview of the Asian Journey.* Ed. Walter Capps. New York: Crossroad, 1989

RJ *The Road to Joy: The Letters of Thomas Merton to New and Old Friends.* Ed. Robert E. Daggy. New York: Farrar, Straus & Giroux, 1989

RM *Run to the Mountain: The Story of a Vocation.* The Journals of Thomas Merton, vol 1: 1939–41, ed. Patrick Hart. San Francisco: HarperSanFrancisco, 1995

RU *Raids on the Unspeakable.* New York: New Directions, 1966

SJ *The Sign of Jonas.* New York: Harcourt Brace Jovanovich, 1953

SS *A Search for Solitude: Pursuing the Monk's True Life.* The Journals of Thomas Merton, vol 3: 1952–60, ed. Lawrence S. Cunningham. San Francisco: HarperSanFrancisco, 1996

SSM *The Seven Storey Mountain.* New York: Harcourt, Brace, 1948

TB "Tom's Book." Unpublished manuscript, The Thomas Merton Archives. Louisville, Ky.: The Thomas Merton Center

TMA *Thomas Merton in Alaska: The Alaskan Conferences, Journals and Letters.* Ed. Robert E. Daggy. New York: New Directions, 1988

TME *The Thomas Merton Encyclopedia.* Ed. William H. Shannon, Christine M. Bochen, and Patrick O'Connell. Maryknoll, N.Y.: Orbis Books, 2002

TS *Thoughts in Solitude.* New York: Farrar, Straus & Cudahy, 1958

TTW *Turning Toward the World: The Pivotal Years.* The Journals of Thomas Merton, vol. 4: 1960–63, ed. Victor Kramer. San Francisco: HarperSanFrancisco, 1996

VC *A Vow of Conversation: Journal, 1964–65.* Ed. Naomi Burton Stone. New York: Farrar, Straus & Giroux, 1988

WF *Witness to Freedom: Letters in Times of Crisis.* Ed. William H. Shannon. New York: Farrar, Straus & Giroux, 1994

WN "Working Notebooks." Unpublished manuscripts, The Thomas Merton Archives. Louisville, Ky.: The Thomas Merton Center

THOMAS MERTON *Photograph by Sibylle Akers; used with permission of the*
Merton Legacy Trust

IMPRESSION FROM THE RUBBER STAMP MADE FOR THOMAS MERTON BY FR. AELRED
Photo #35-40-31

"On Monday Fr. Aelred left, which was wise and the only solution—he was getting no education here and would only get into complications. So now he is gone and has left no memorial other than a spot of wine on the altar cloth—and the little India rubber eraser on which he carved my name so that with our ink pad I can stamp it on books etc. I like the way it is done, rough and crude and simple."

(*Turning Toward the World,* August 5, 1960)

The Landscape of His Divinely Appointed Place

JOHNATHAN MONTALDO

The object of pilgrimage is to take the monk to his peculiar and appointed place on the face of the earth, a place not determined by nature, race, and society, but by the free choice of God. Here he was to live, praise God and finally die. His body is buried in this spot, and would there await the Resurrection. The pilgrimage of the Celtic monk was not then just endless and aimless wandering for its own sake. It was a journey to a mysterious, unknown, but divinely appointed place, which was to be the place of the monk's ultimate meeting with God.[1]

—THOMAS MERTON

YOU HAVE OPENED A BEAUTIFUL BOOK with many windows. This stunning collaboration of photographs and text offers vistas of reflection upon a landscape in Nelson County, Kentucky, long bound over for holiness through prayer since 1848, when French Trappists journeyed across seas to cultivate a small portion of American farmland as their place for an "ultimate meeting with God." By the sweat of their labor, the tears of their prayers, and their silences from the world's ten thousand things, these French monks baptized their "divinely appointed" site the Abbey of Our Lady of Gethsemani.

In April 1941 twenty-six-year-old Thomas Merton made the first of two pilgrimages to Gethsemani. He traveled south by train while on Easter holiday from western New York, down through the Ohio Valley from Saint Bonaventure College, where he was a first-year teacher of English literature. Like many who had made the journey before him, Merton traveled to

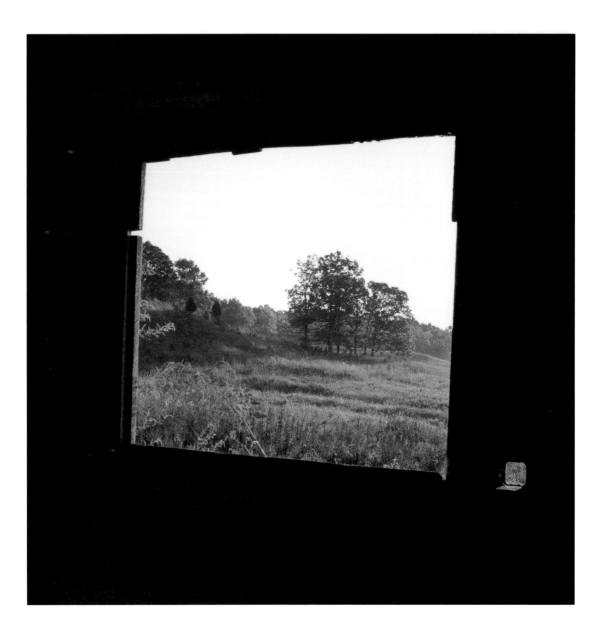

ONE OF GETHSEMANI'S FARM FIELDS VIEWED THROUGH A BARN WINDOW *Photograph by Thomas Merton; used with permission of the Merton Legacy Trust*

"I looked out the window at the narrow rocky valley beyond the novitiate parapet, and the cedar trees beyond and the bare woods on the line of jagged hills. *Haec requies mea in saeculum saeculi, hic habitabo quoniam elegi eam!*" [Here is my resting place forever, here I will live because I have chosen it.] (*The Seven Storey Mountain,* 385)

Gethsemani only to make a few days' retreat in the guesthouse at the abbey, situated fifty-five miles south of the city of Louisville.

On November 16, 1938, less than three years before his first train ride to Kentucky—while still a twenty-three-year-old graduate student at Columbia University in New York City—Merton bowed his forehead to the baptismal font at Manhattan's Corpus Christi Church. Soon thereafter, he had hoped to become a priest and a Franciscan, but he was prevented from doing so. Teaching at Saint Bonaventure in Olean, New York, he had chosen to live like a friar, structuring his teaching day by devotions and psalms. But Merton's religious imagination was still pressing him forward, and he had remained restless for a place and a vocation that would bind him over to seeking "God Alone." As he traveled to Gethsemani in April on retreat to celebrate the feast of Christ's passing over from death to resurrection, Merton may have prayed for his own sacred moment of passing over to a new life. Perhaps Gethsemani would provide the setting for an inner earthquake, a breaking up of the fallow ground of his past experiences that would plant in him the foundations of a new world. Perhaps he suspected that his journey to Gethsemani would—as it, in fact, did—make him want

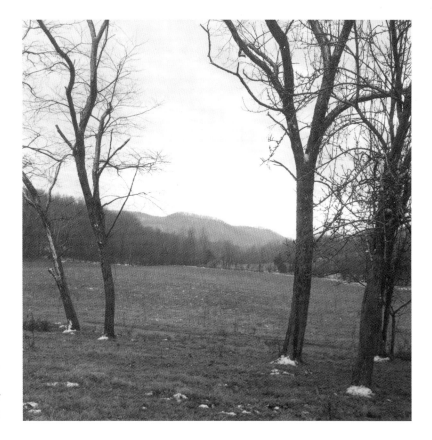

A WINTRY VIEW
OF FIELDS AND
DISTANT HILLS
*Photograph by
Thomas Merton;
used with permission of
the Merton Legacy Trust*

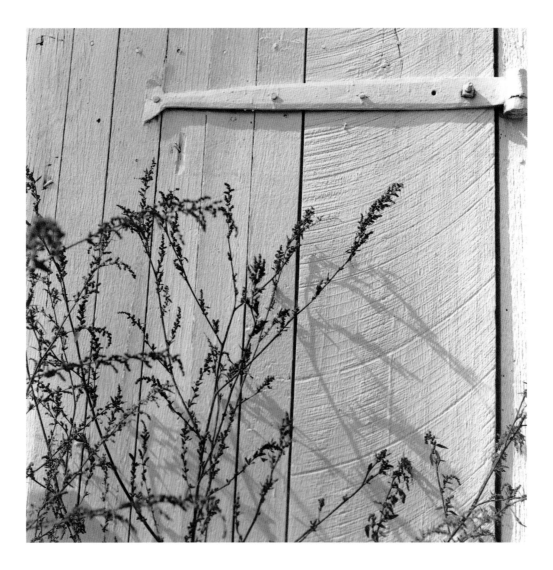

WEEDS AGAINST THE WHITEWASHED SHEEP BARN *Photograph by Thomas Merton; used with permission of the Merton Legacy Trust*

to tear out all the pages of the private journals he had written up until the moment of his arrival at Gethsemani[2] and begin again the account of his life on a brand new page. He perhaps hoped—and his hope would be fulfilled—that Holy Week at Gethsemani would be his bridge to a new spiritual terrain, to an unexplored geography of his heart that Gethsemani herself would show him.

As he passed through Gethsemani's narrow gate inscribed with greetings of peace to all who entered—*Pax Intrantibus*—Merton's heart experienced a shift into higher gears. Through Gethsemani's gate Merton sped past all his current hopes for himself. Now that his becoming a priest seemed impossible, he at least had hoped for a life of teaching or journalism and had wished for himself at best the status of published poet and novelist. But now, passing through a new gate, Merton narrowed his gaze upon these few acres the monks inhabited, enclosed by walls around an axis formed by a silver-painted tin steeple that rose above the abbey's church. Beyond this tight enclosure, Merton saw how the abbey embedded itself within farm-lands, knobs, and forests. The monastery's natural landscape immediately appealed to Merton, but its actual fortresslike main building, with its church housing sixty monks—singing together in communal prayer night and day but otherwise keeping to themselves, dressed in simple clothing and with sparse food grown by the toil of their own hands—would only slowly attract Merton's undivided attention. As he prayed with the monks in their church and admired the fruits of their labors upon their land, Gethsemani's silences rose up toward Merton to create a dialogue with him through the back door of his heart.

It is true, as Merton recorded in his journals and letters, that the conflicting voices in his head were alarmed at even the imaginative prospect of his trying out a commitment to this narrow Kentucky terrain and to its even narrower silences.[3] His heart's competing desires warned him that for the survival of his profound attachment to their complex tensions, he should flee this uncomplicated place. But argument faded as Merton slipped down into the healing silence he was encountering at Gethsemani's every corner. As he adopted a slower pace through days of paschal liturgy, Merton discovered that Gethsemani was imprinting a new and ordered movement upon his soul. Gethsemani was teaching Merton a choreography other than Manhattan's wild dance, which had always sent him restlessly out into the night and the city's bars and jazz joints to swag-ger about with his Columbia buddies, peacocks getting drunk on beer and looking to entice loose dames. These first April days at Gethsemani, by contrast, were encouraging Merton's revolt "against the meaningless confu-sion of a life in which there was so much activity, so much movement, so

much useless talk, so much superficial and needless stimulation, that I could not remember who I was."[4] Gethsemani was marking out for Merton the boundaries of her place in order to bring him peace, to envelop him in her quiet so that he could finally remember who he was, and more promisingly, to permit him to explore the inner depths of who he might become if only he could be naturalized a citizen of this monastery, which he enthusiastically baptized in his journals as "the only real city in America."[5]

On December 10, 1941, Merton made a second pilgrimage to Gethsemani. Bound once again for Kentucky on a train, Merton finally handed himself over to a providence that he had never dared hope existed for him. Writing twenty-five years later in his journals, Merton recalled that he had walked through Cincinnati's train station on this final trip with the words of Proverbs 8 on his lips: "And my delights were to be with the

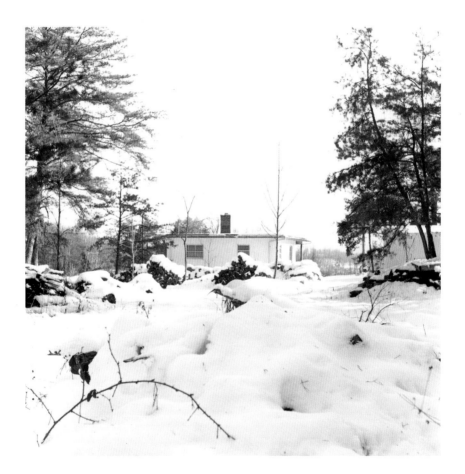

REAR VIEW OF THE HERMITAGE IN HEAVY SNOW *Photograph by Thomas Merton;*
used with permission of the Merton Legacy Trust

children of men." He reminded himself how he had traveled to Gethsemani in December under the influence of Lady Wisdom.[6] Wisdom as mother—the Mother of God—and Wisdom as protector and teacher—Our Lady of Gethsemani herself—were guiding him back to this place among brothers that was to be his salvation and his home, his own divinely appointed place where he could remain hidden in the secret of God's face. In his autobiography *The Seven Storey Mountain,* Merton would flesh out this entire movement of his youth—from the time he left England under a cloud, bound for New York aboard a ship, up to this moment of arriving at Gethsemani—as having unfolded under the aegis of Wisdom's loving hands:

> Lady, when on that night I left the Island that was once your England, your love went with me, although I could not know it, and could not make myself aware of it. And it was your love, your intercession for me, before God, that was preparing the seas before my ship, opening the way for me to another country.
>
> I was not sure where I was going, and I could not see what I would do when I got to New York. But you saw further and clearer than I, and you opened the seas before my ship, whose track led me across the waters to a place I had never dreamed of, and which you were even then preparing for me to be my rescue and my shelter and my home. And when I thought there was no God and no love and no mercy, you were leading me all the while into the midst of His love and His mercy, and taking me, without my knowing anything about it, to the house that would hide me in the secret of His Face.[7]

Ever since the first monks arrived in 1848, countless pilgrims have made their own journeys to Gethsemani. Increasingly, following the publication of Merton's widely appreciated autobiography in 1948, some have traveled to Gethsemani to emulate Merton's quest for a spiritual home. Merton's story of having discovered Gethsemani as his own "city on a hill" has encouraged many pilgrims to reserve a portion of the abbey's landscape for their own meeting with God. Gethsemani's pilgrims have hallowed her fields as they joined their yearning to the psalms of the monks. Wave after wave, in rhythms of desire and satisfaction, these pilgrims have kept coming. Personages known throughout the world and ordinary folk known only to family and friends—Gethsemani receives them all, whether arriving in company or having stumbled toward her alone. For all who come to visit the most famous Cistercian monastery in America, and for those who come specifically to till for themselves the spiritual landscape of Thomas Merton's

A DETAIL OF THE INTERIOR OF THE ABBEY CHURCH *Photograph by Thomas Merton; used with permission of the Merton Legacy Trust*

place, Gethsemani continues to reveal her hospitable country. Bounded on all sides by her charity, Gethsemani's geography has become for many a "privileged and holy place, a center and source of indefectible life."[8]

The texts of Merton's journals, and especially many of his best poems, continually point to his recognition of Gethsemani's landscapes—each concrete and particular dimension of "the place and the brothers"—as marking out the providential space chosen for him by God to seek and then to "drink the waters of life."[9] Virtually everything Merton wrote about Gethsemani as providential landscape was his way of fashioning metaphors for Wisdom's guidance of the province of his heart. His writing always acknowledged his inner experience of continuity "between the natural and the supernatural, between the sacred and the profane, between this world and the next: continuity both in time and/or space. . . . The deepest and most mysterious potentialities of the physical and bodily world, potentialities essentially sacred, demanded to be worked out on a spiritual and human level."[10]

Merton's journals and his poetry—perhaps everything he wrote—were media for his becoming a man of prayer. He wrote of his encounters with people and books and "the wind through the pine trees" as a form of prayer that gave him access to a heart-place where he could "enter the school of his life."

In notes that he wrote for his monastic novices on the occasion of a conference, Merton reflected upon what appears to have been a central aspect of his own prayer. One way of praying that his conference notes developed was to enter into a continual process of "assimilating God's words," offered to the monk in books, in the teaching afforded by spiritual directors, and, most important, in finding God's "words" mediated by "experience" itself: "We cannot be true monks if we do not assimilate and *make our own* the teaching that is given us from morning to night by God our Father." The Father's wisdom teaching was intimately bound up with "the many instances of His mercy" in their lives and with all the "evident signs of His loving protection."

Merton advised his novices to seek "the mark of God's love and God's wisdom imprinted in the unique identity" given to each of them through the individual development of their monastic vocations. He reassured them that their entire lives—before arriving at the monastery and now as monks—were experiencing a "gradual development under the secret action of nature and the creative hand of God": "Meditation," Merton wrote with emphasis, "enables the monk to *enter deeply into the school of life itself,* to make the monk's whole life a meditation, a learning from God, a school of wisdom, *a clear-sighted and humble cooperation with the wisdom of divine Providence in our lives,* a ceaseless effort *to please our Heavenly Father* by

receiving His secret instruction, in all events, by learning from His holy will, and living constantly under his gaze. *Meditatio* is not just praying with ideas but is fed by realities."[11]

One set of these "realities" that continually fed Merton's own meditations was his monastery's landscapes, with their populations of animals and winged creatures that coexisted under a wide and ever-changing sky. These natural, concrete "realities" manifested for Merton different "words" of God's wisdom. They spoke to him with different inflections as the seasons changed—including the fluctuations of his own heart—as beloved buildings were demolished or destroyed by fire, or his secret woods were cleared of trees. Merton prayed by paying attention to the wordless order lovingly imposed on his world at Gethsemani by light and darkness at the sacred hours of lauds and vespers. To gaze lucidly and attentively upon nature's signs to him—like those offered by "the speech that rain makes"[12]—was a means for Merton to transcend his conflicted inner life by embedding himself in a larger world of "creeping and crawling things"[13] that functioned like a chorus, beckoning him to appreciate his natural life as "essentially realistic and concrete." Merton knew himself to be essentially uncomplicated as he gazed upon the natural world of his monastic surroundings. What he called the "reality of life itself" taught him a simple way to be a monk, namely, "One lives and loves."[14] As he explained: "To deliver oneself up, to hand oneself over, entrust oneself completely to the silence of a wide landscape of woods and hills . . . to sit still while the sun comes up over that land and fills its silences with light. To pray and work in the morning and to labor and rest in the afternoon, and to sit still again in meditation in the evening when night falls upon that land and when the silence fills itself with darkness and with stars."[15]

Merton's writing about nature was his way of attentively inserting himself into a deeper relationship with nature's singularities and so to take his divinely provided place at life's banquet. His nature writing reveals that a basic element of his quest for God was to bind himself over and over again in conversion to this particular Kentucky place where his eyes opened every morning. As he attended to the "silence of the forest, the peace of the early morning wind moving the branches of the trees, the solitude and isolation of the house of God," these natural elements of his daily life served as vehicles for God's messages to Merton. They occasioned the moments when "God best likes to reveal Himself most intimately."[16]

Merton's nature writing at Gethsemani is uniformly joyful. He experienced unwavering consolation from the abbey's natural setting. Writing about this landscape was his way of harvesting his happiness about being a monk. Merton knew that he had been called to cultivate the spiritual gifts

of this particular vineyard. His words always incarnate the unique tastes of his encounters with God, embodied in the varying climates of his monastic setting. Gethsemani became for Merton the concrete "special place on earth" that gave his life order and truth. The words he used to express his love for Gethsemani as a unique place were saturated with the psalms of the Bible that he prayed and sang every day:

> The Bible has always taken man in the concrete, never in the abstract. The world has been given by God not to a theoretical man but to the actual beings that we are. If we instinctively seek a paradisiacal and special place on earth, it is because we know in our inmost hearts that the earth was given us in order that we might find meaning, order, truth, and salvation in it. The world is not only a vale of tears. There is joy in it somewhere. Joy is to be sought, for the glory of God.[17]

Although he lived in Lexington, Kentucky, not far from the monastery, photographer Harry Hinkle came to Gethsemani as a stranger to its ways and, for the most part, to the writing of its most famous monk. His interests as pilgrim photographer focused more on the monastery's natural landscapes than on its monk-made ones. Hinkle more naturally appreciated Gethsemani's less cultivated and wilder margins, which help cushion "the world" from the monastic buildings humming with work and psalmody. Although he made his pilgrimage to Gethsemani to experience its landscapes for himself, to "see" them through his camera lens, Hinkle was virtually—and probably half-consciously—following in the tracks of Merton's own preferences for Gethsemani's more wild and silent margins. In Gethsemani's hidden and isolated places Hinkle allowed his camera to soak up the mostly unheard speech that the land itself utters when human voices are silent. In Hinkle's photographs of Gethsemani's wild places he was, like Merton, listening in particular for a "word" born of silence.

Monica Weis, a professor of American literature, has created her own path for a pilgrimage around Hinkle's photographs. She has harvested Merton's writing for his descriptions of the nurturing role of natural landscapes, such as Gethsemani's "mothering hills,"[18] that produced the providential settings where Merton could live out his union with God through acts of contemplation. Weis's close study of Merton's nature writing permits her to focus on Merton's favorite Gethsemani locales, like his first hermitage, a tool shed dragged out into the woods specifically for him, which Merton christened "St. Anne's" in his journals. Weis reflects deeply upon Merton's encounter with Gethsemani's natural setting as a mirror of his

encounters with God's "wisdom," which shone in the water courses that flowed through Merton's silence and reflected the warm light of stars that lit up Wisdom's landscape for his monastic life.

No one, however, can presently revisit "Thomas Merton's Gethsemani." Although many of the natural landscapes he loved as settings for his sacred work are still there, the living reality of what Gethsemani was for him exists now only in his writing, in his drawings, and in his photography. "Merton's Gethsemani" today is probably confined to whatever remains of him under the simple white cross that marks his grave.

Within Merton's own lifetime Gethsemani was already being transformed from the place he had traveled to in December 1941; Gethsemani as it appears today is in many ways changed since the year of Merton's death in 1968. The old sheep barn, which Merton considered its most beautiful structure, is gone. The separate novitiate building where he taught newcomers to Gethsemani was demolished in his lifetime to clear ground for a new infirmary. Merton celebrated the burning of the cow barn in a famous poem.[19] The legendary monastic gate he had passed through during Advent in 1941 to enclose himself within Gethsemani, with its reception rooms on one side and the store and post office on the other, is gone, although the gatehouse's bell, by means of which Merton and thousands of pilgrims like him had announced themselves, has fortunately been preserved. The church Merton knew for almost his entire monastic life was drastically renovated in 1966. The famous bell tower, with its tin steeple, which Merton famously described himself climbing one night in July 1952,[20] has rotted in the woods, where someone had hauled it during the church's renovation. The book vault Dom James had allowed Merton to use for writing and praying alone is now part of the Skakel Guest Chapel. The tool shed he loved as his first real hermitage, "St. Anne's," is a slowly rotting ruin encroached by woods.

So the real memorial to all these "Merton places" at Gethsemani is best encountered in his journals and his poetry. Yet even these places that he immortalized—especially his hermitage on Mount Olivet, where continuously he lived alone from 1965 until his death and which he called his "house"—were never Merton's possessions. Merton lived, like all the monks at Gethsemani before and after him, as a pilgrim on his land. Like all monks, Merton was always in spiritual transition. He was often tempted to leave his "divinely appointed place" and go elsewhere to seek some more perfect place, but he stayed on. Although often loving his stability in Kentucky, Merton—like all monks, really—always looked beyond his provincial horizons toward another country, for a different and better "divinely appointed" place beyond the house and the lands where they once came in

joy to live and pray "at home." No doubt there are moments experienced by all monks when they feel themselves almost arriving into the harbor of that other country, when it arises out of the mists of their prayers and their yearning to see it. But these moments pass. While monks live, the real country for which they are always searching remains elusive. Merton was no different. While he always yearned for another, better place beyond Gethsemani, he decided to stay where he was and sail his inner seas.

Thanks to the fortuitous collaboration of a writer and a photographer, we can now make our own virtual pilgrimage to Gethsemani, to those places where Merton struggled with the angels who bore him messages from God. With the help of these two guides, we can create our own paths around the man-made architecture of Merton's monastic life, where he was sheltered within his community, and follow him out into Gethsemani's fields, its knobs, its water-fed places, and among its trees, where he hid himself in solitude and sought the company of a wider world of creatures whose simple beauty was more appealing than anything his official monastic world offered him.

Thomas Merton's Gethsemani affords the reader wonderful opportunities to reflect upon Gethsemani's man-made and natural, sacred landscapes. By means of words and through photographs the book's collaborators enable Gethsemani to become for us our own epiphany. They permit it to sing to us beyond itself, to that most holy of holy landscapes for which we all yearn. This book does not invoke an image of a pilgrimage as the "restless search of an unsatisfied romantic heart." Rather, it appreciates what Merton himself understood about the necessity for everyone to be a pilgrim. Pilgrimage, Merton wrote, is "a profound and existential tribute to the realities perceived in the very structure of the world . . . a sense of ontological and spiritual dialogue between man and creation in which spiritual and bodily realities interweave and interlace themselves." The pilgrim's vocation is that of everyone. Being always on pilgrimage, we experience the need to become more deeply human beings as a call "to mystery and growth, to liberty and abandonment to God . . . in witness to the wisdom of God the Father and Lord of the elements."[21]

Let the readers of this book find a message within its pages that inspires them joyfully to move forward on their own pilgrimage. Let the virtual visit to Gethsemani provided by this book return its readers to their own homes, the veritable sacred landscapes where everyone lives each day. Yet this special book should also provide another call for us to realize, beyond what we know, the pull of another country, that "hidden ground of love"[22] with God and all our neighbors that, at the end of our separate journeys, will be our true home.

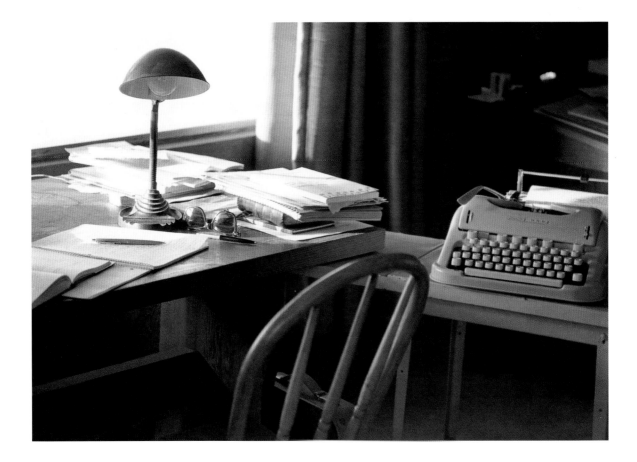

MERTON'S DESK AND TYPEWRITER AT THE HERMITAGE *Photograph by Thomas Merton; used with permission of the* *Merton Legacy Trust*

At Gethsemani's Invitation

Every road you have ever taken, and
All the corners you have ever turned
Have led you to my gate,
To my way for you to paradise,
Once you open it with your prayers.

Wisdom articulates herself in my house.
She knows each one who enters.
She whispers from every corner.
She gives nourishment without fuss.
She will take off your shoes.

Enter this place carefully,
And Wisdom will teach you everything.
Hush your heart, become her intimate:
Wisdom will enter your soul
And make herself at home.

My walls are perfumed with the prayers
Of pilgrims here long before you.
Join yourself now to their prayers.
Find your own way on their sunlit map
While Wisdom illuminates your own road toward joy.

—Jonathan Montaldo
December 10, 2004

STARS TWINKLING ON A BRISK WINTER NIGHT *Photo #39-59-15*

"The shadows fall. The stars appear. The birds begin to sleep. Night embraces the silent half of the earth. A vagrant, a destitute wanderer with dusty feet, finds his way down a new road. A homeless God, lost in the night, without papers, without identification, without even a number, a frail expendable exile lies down in desolation under the sweet stars of the world and entrusts Himself to sleep." (*Hagia Sophia*)

Discovering the Earthly Paradise

HOLY WEEK 1941. A time for savoring the great mystery of our redemption—a time of excitement and unknown horizons for the recently converted Thomas Merton. While teaching literature at Saint Bonaventure College in upstate New York, Merton had adopted the habit of meditating in the nearby pastures and reciting the Divine Office by himself. Yet he was still restless and unsatisfied. At the urging of Dan Walsh, his former teacher and mentor, Merton arranged to make a retreat at Gethsemani, a little-known Trappist monastery in the wilds of central Kentucky. Perhaps there his heart would find some answers and his pilgrim's yearning would be satisfied.

It was a long trip. Traveling a full day by train to Cincinnati, a second day to Louisville, and then on to the little hamlet of Bardstown by car, Merton finally arrived at the monastery after dark. The "silence and solitude of the Kentucky hills" spoke to his soul. The "rolling country" and the "pale ribbon of road . . . stretching out as grey as lead in the light of the moon" greeted him. Suddenly emerging out of the darkness, a steeple "shone like silver in the moonlight, growing into sight from behind a rounded knoll. The tires sang on the empty road, and, breathless, I looked at the monastery that was revealed before me as we came over the rise. . . . [T]he whole place was as quiet as midnight and lost in the all-absorbing silence and solitude of the fields." A "dark curtain of woods" behind the monastery and a "mild, gentle Easter moon" smiled "over all the valley . . . loving this silent place" (SSM 320). Merton also shared that love.

Once inside the monastery, the beauty of the liturgy and the rigor of the lifestyle captivated Merton. Its deep silence spoke to him "more eloquently than any voice." In the chapel, listening to the chanted psalms that guided and punctuated the hours of the monks' day, Merton experienced the whole earth coming to "new fruitfulness and significance." He had visited Rome and spent hours gazing at ancient classical art and magnifi-

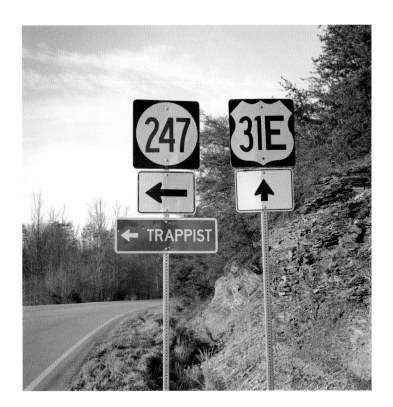

SIGN ON HIGHWAY 31E SOUTH OF BARDSTOWN, KENTUCKY

Photo #MF47-01

"You need not hear the momentary rumors of the road

Where cities pass and vanish in a single car."

("The Trappist Cemetery—Gethsemani," *Collected Poems,* 116)

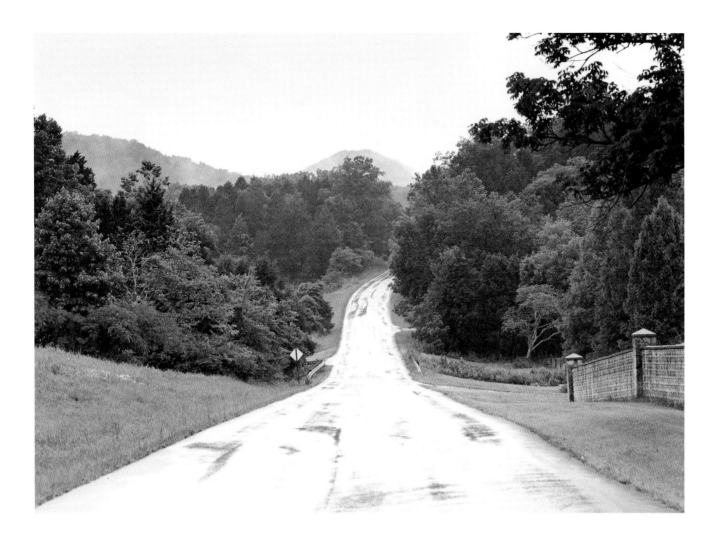

MONKS ROAD, IN FRONT OF THE ABBEY OF GETHSEMANI, AFTER A RAIN *Photo #MF34-07*

"Nothing can spoil this morning. The rain has stopped. The birds sing and starlings pursue a crow across the grey sky. Clouds still hang low over the woods. It's cool." (*A Search for Solitude,* May 18, 1959)

cently ornamented Christian churches, but Gethsemani's budding leaves, tulips, and bees displayed even more profundity (RM 347). He saw the "beauty, . . . order and cleanness" of the monastery as a modern expression of the ideal of medieval Christian culture that all things were to be enjoyed not for themselves alone but as facilitating communion with God. He saw the daily routine of prayer and work (*ora et labora*) as a form of play because these duties were performed freely out of love.

Gethsemani, then, was not on the fringe of the civilized world, but its utter simplicity and single-minded devotion to God made it "the center of America. I had wondered what was holding this country together, what has been keeping the universe from cracking in pieces and falling apart. It is this monastery if only this one. . . . This is a great and splendid palace. . . . I tell you I cannot breathe" (RM 333).

Merton's life would never be the same. He longed to be part of the community yet felt like a thief stealing into a forbidden place, a murderer rushing to the "King whose Son I murdered—to the Queen, too," pleading for mercy (RM 334). Moreover, Merton felt constrained by what he considered his Franciscan spirituality. Must he relinquish his love of trees, woods, and hills to become a Trappist? Would "God Alone" and rejection of the world (*contemptus mundi*) mean pretending that only matters of the spirit held any value?

Back at Saint Bonaventure, Merton struggled with his conundrum. He prayed frequently before the statue of Saint Thérèse of Lisieux on the college grounds: "You show me what to do. . . . If I get into the monastery, I will be your monk." One night during prayer Merton heard in his imagination the bell at Gethsemani signaling the end of night prayer. "The bell," he wrote in *The Seven Storey Mountain* "seemed to be telling me where I belonged—as if it were calling me home" (SSM 364–65).

Merton's longing for the peace he had experienced at Gethsemani eventually helped him decide that religious discipline did not exclude a love of nature. As a Trappist monk he could have affection for nature as long as he regarded it as part of God's creation and a sign of divine goodness (RM 399). And so, on December 10, 1941, Merton once again made the long train journey to Gethsemani, this time to stay in the community as Frater Maria Ludovicus, Brother Louis. Despite his youthful enthusiasm for this world—its colors, its breezes, its creatures—Merton felt obliged to maintain a certain detachment from creation. Nature, he reasoned, was a gift to be used only as a stepping-stone to the Godhead. Creatures could be appreciated but not settled on. Matter was one thing; spirit another.

However, this dualistic view of nature did not remain with him. Nature itself and long periods of silent prayer showed Merton how God

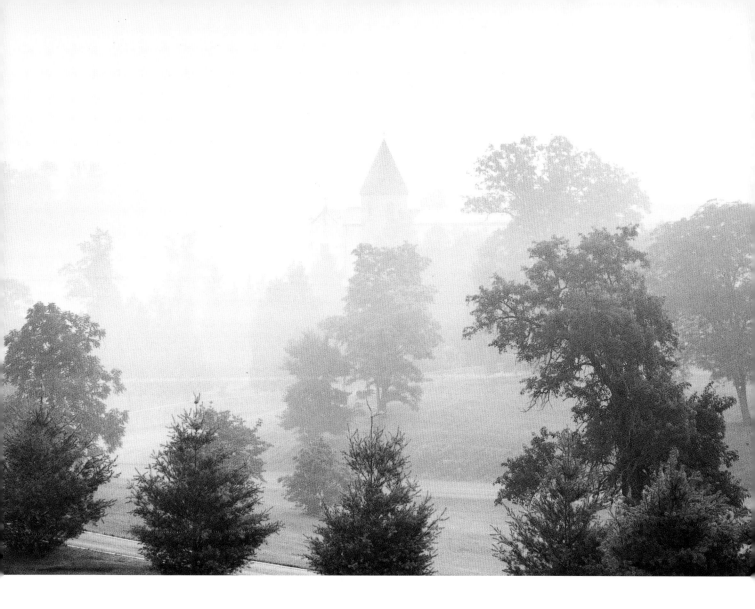

MORNING MIST AND FOG OVER THE ABBEY *Photo #*MF27-4

"When the full fields begin to smell of sunrise

And the valleys sing in their sleep."

("The Trappist Abbey: Matins," *Collected Poems*, 45)

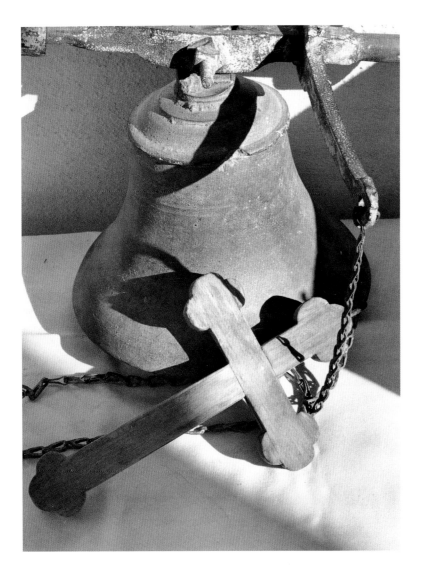

BELL FROM THE OLD ABBEY GATEHOUSE
Photo #35-44-20

"Bells are meant to remind us that God alone is good, that we belong to Him, that we are not living for this world.

They break in upon our cares in order to remind us that all things pass away and that our preoccupations are not important.

They speak to us of our freedom, which responsibilities and transient cares make us forget.

They are the voice of our alliance with the God of heaven.

They tell us that we are His true temple. They call us to peace with Him within ourselves." (*Thoughts in Solitude*, 67)

MERTON'S SIGNATURE IN THE GETHSEMANI GUEST REGISTER, APRIL 1941
Photo #35-R35-08

was available to him in the geography of Gethsemani. In the early-morning hours after night office and silent prayer, Merton loved to read commentaries on the psalms he had just chanted in the chapel. Especially in the summer, when he could pray under the trees, he reveled in the "shades of light and color" that filled the woods. "Such greens and blues as you never saw! And in the east the dawn sky is a blaze of fire where you might almost expect to see the winged animals of Ezechiel, frowning and flashing and running to and fro" (SSM 390). One of Merton's journal entries, written several years after his entrance into the monastery, is particularly revealing. He describes the liturgical ceremonies of the previous evening, then comments on the way the "low-slanting rays [of the setting sun] picked out the foliage of the trees and high-lighted a new wheatfield against the dark curtain of woods on the knobs that were in shadow. It was very beautiful. Deep peace. . . . I looked at all this in great tranquility, with my soul and spirit quiet. For me landscape seems to be important for contemplation . . . anyway, I have no scruples about loving it" (ES 216).

It is clear from this last statement that Merton was experiencing significant spiritual growth. The monastic ideal of unifying all aspects of one's life was taking root in his being. Merton was not only *looking* at the tranquility of nature but also beginning to understand how he, too, was part of the silence and peace of the landscape. As a new monk Merton was striving to integrate prayer, work, reading, and silence into a coherent spirituality; he was also allowing his love of nature to be a constructive force in shaping his imagination and ultimately developing a sense of place.

Thomas Merton had always loved nature. From his earliest days in Prades, France, the village of his birth, Merton had delighted in color and light. The village itself, dominated by Canigou Mountain, is a chiaroscuro world of glaring light and looming shadows defined by edges of buildings and natural vegetation. In "Tom's Book," the record his mother was keeping for the New Zealand grandparents, Ruth Merton recorded several instances of Tom's growing awareness of his surroundings. In those early months Baby Tom "had already begun to wave his arms toward the landscape, crying 'O color!' ('Color' is the word he uses to mean landscape, his father's pictures and all the paraphernalia of painting)" (TB 7). A sample horarium of young Tom's day indicates extensive time outdoors after his 7:30 A.M. breakfast until his bath at 10:30 A.M. and again after his 2 P.M. dinner until sunset. Much of this time out of doors could have been spent near his father, Owen, while he painted. There, patterns of light and color—from nature and from the canvas—became part of Merton's informal schooling in landscapes. "When we go out," wrote his mother, "he seems conscious of everything. Sometimes he puts up his arms and cries out 'Oh Sui! Oh joli!'

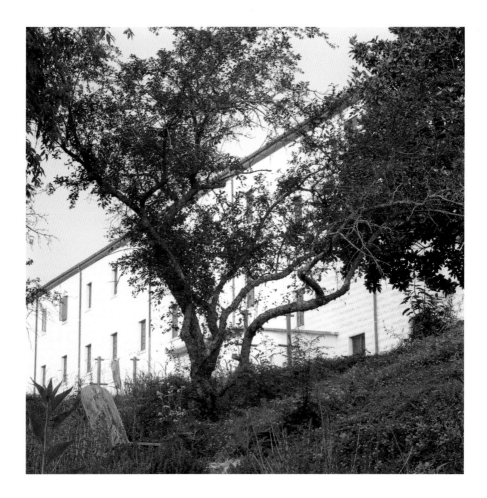

A VIEW OF THE MONASTERY'S EAST WALL FROM THE ORCHARD *Photo #*MF 26-05

"The long yellow side of the monastery faces the sun on a sharp rise with fruit trees and beehives. I climb sweating into the novitiate, put down my water bottle on the cement floor. The bell is ringing. I have some duties in the monastery. When I have accomplished these, I return to the woods."

(*Dancing in the Water of Life,* May 1965)

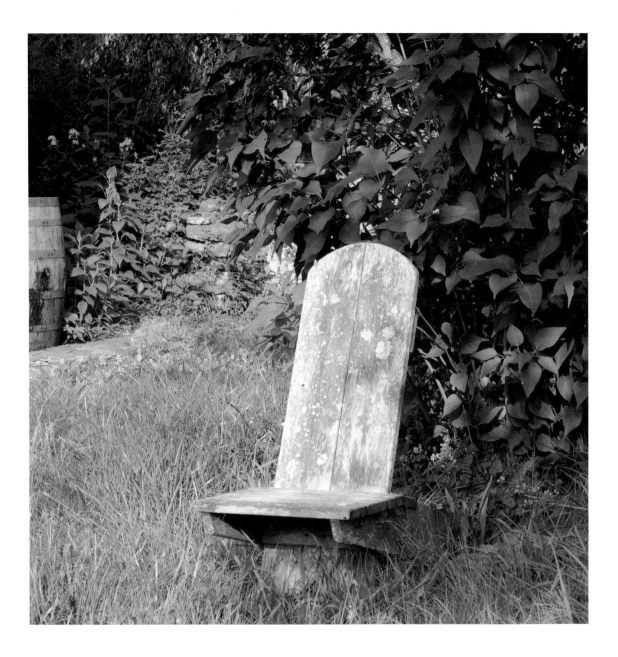

A WOODEN CHAIR AT THE EDGE OF THE ORCHARD *Photo* #MF24-04

"When the white orchards dream in the noon

And all those trees are dens of light."

("Spring: Monastery Farm," *Collected Poems*, 170)

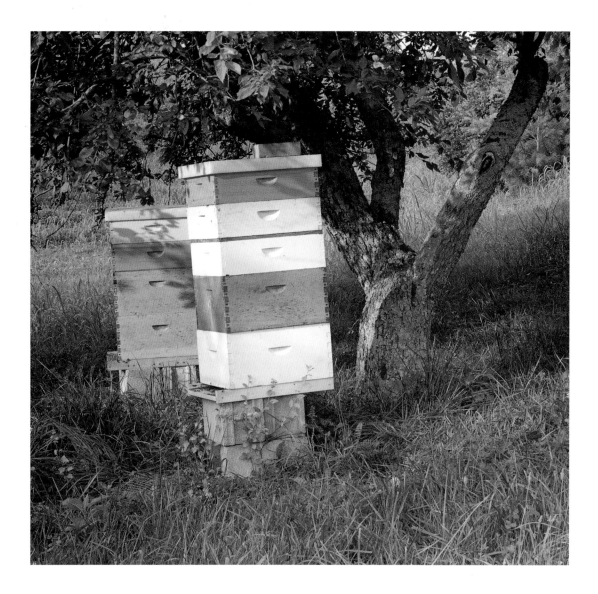

BEEHIVES NEAR AN APPLE TREE *Photo #* MF 26-12

"Here I sit surrounded by bees . . . working in the delicate white flowers of the weeds among which I sit. I am on the east side of the house where I am not as cool as I thought I was going to be, and I sit on top of the bank that looks down over the beehives and the pond where the ducks used to be and Rohan's Knob in the distance." (*Entering the Silence,* July 10, 1949)

AN EARLY-MORNING VIEW OF THE LIBRARY AND BARNS *Photo #MF11-12*

". . . the grey and frosty time

When barns ride out of the night like ships."

("After the Night Office—Gethsemani Abbey," *Collected Poems*, 108)

Often it is to the birds or trees that he makes these pagan hymns of joy. Sometimes he throws himself on the ground to see the 'cunnin' little ants' (where he learned that expression, I do not know!)" (TB 6–7).

At Gethsemani Merton continued to delight in the landscape's colors, its shades of light and dark, its subtle and vibrant voices, and its multiple revelations of the God he came to know and love intimately. He spent as much time as possible out of doors, wandering the hills and valleys of the monastery property, meditating by the side of its lakes, and discovering the impact of this greater solitude on his contemplation. In the last years of his life Merton received permission from his abbot to spend most of his time at a hermitage in the woods located about a mile from the monastery buildings. In these woods—with the rain, birds, trees, and deer for company—Merton came to understand more deeply his vocation to live the solitary life of a monk, apart from the world, but a solitude that blossomed into compassion for the world. The journals that Merton kept before and during his twenty-seven years as a Trappist monk—containing more than 1,470 references to nature—reveal how frequently he noticed his surroundings and how much nature influenced his thinking and his prayer.

A VIEW OF THE
SOUTH SIDE OF
THE SHOPS
BUILDING
*Photo #*MF48-02

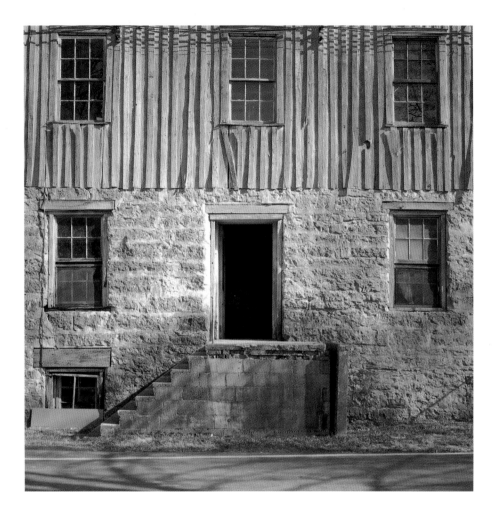

DOORWAY, WINDOWS, AND STEPS OF THE SHOPS BUILDING *Photo #*MF48-01

"So much do I love this solitude that when I walk out along the road to the old barns that stand alone, far from the new buildings, delight begins to overpower me from head to foot and peace smiles even in the marrow of my bones." (*The Sign of Jonas,* March 16, 1950)

A NORTH-FACING WINDOW IN THE SHOPS BUILDING *Photo #*MF25-05

"And look, the ruins have become Jerusalems,

. .

Jerusalems, these walls and rooves,

These bowers and fragrant sheds."

("A Letter to My Friends," *Collected Poems*, 91)

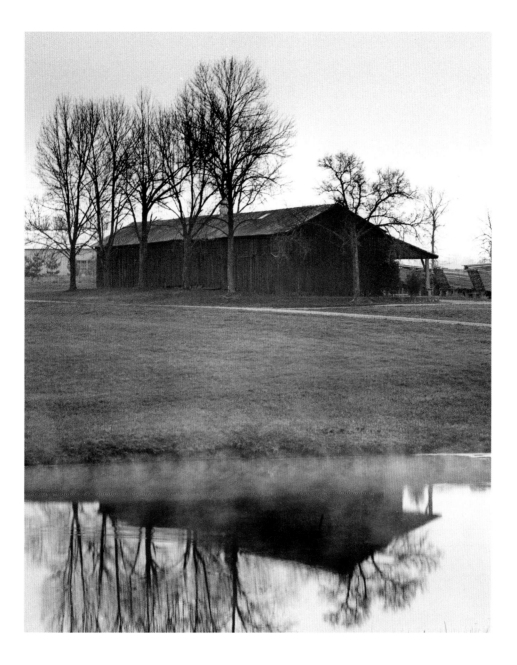

THE WOODSHED REFLECTED IN TROUT POND *Photo* #MF11-09

"Quiet sunset. Cool, still day and another fire over toward Rohan's Knob. Peace and silence at sunset behind the woodshed, with a wren playing quietly on a heap of logs, and a detached fragment of gutter hanging from the end of the roof; bare branches of sycamores against the blue evening sky. Peace and solitude." (*Turning Toward the World,* April 7, 1963)

A CUPOLA WITH A CROSS ATOP THE WOODSHED *Photo #MF49-12*

". . . our Mother, with far subtler and more holy influence,

Blesses our rooves and eaves,

Our shutters, lattices and sills."

("The Evening of the Visitation," *Collected Poems*, 44)

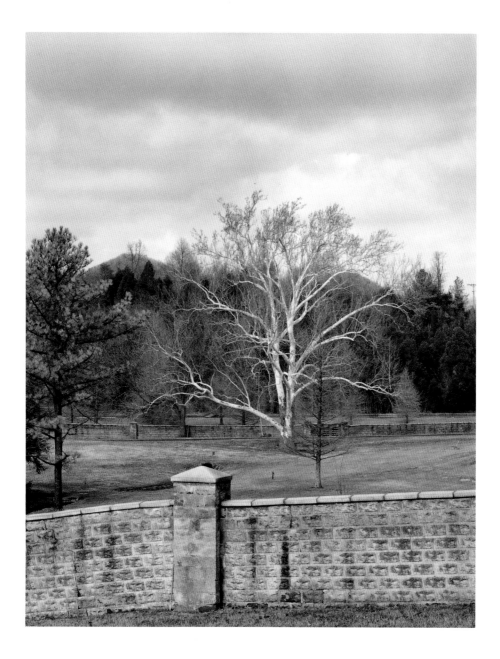

THE MONASTERY WALL ENCLOSES THE RETREATANTS' GARDEN *Photo* #LF16

"This morning after High Mass—a Pontifical High Mass celebrated by the Abbot at 8:30—I walked along the wall of the guest house garden, under the branches of the fruit trees, and in the hot sun, in the midst of more beauty than I can remember since I was in Rome. I remember Rome a lot, here."
(*Run to the Mountain*, Holy Thursday, April 10, 1941)

A TALL CEDAR TREE NEXT TO THE ENCLOSURE WALL *Photo #MF05-07*

"I made a bee-line for the little grove of cedars that is behind the old horsebarn and crowded up against the far end of the enclosure wall and it was nice." (*The Sign of Jonas,* July 31, 1949)

MONASTERY WALL DETAIL IN THE EARLY MORNING *Photo #MF05-05*

"There is a gray wall . . .

.

. . . a place of shelter, full of sun."

("Natural History," *Collected Poems*, 182)

A GATE IN THE ENCLOSURE WALL NEAR THE ABBEY PARKING LOT *Photo #*MF 31-02

"Only when God is our Master can we be free, for God is within ourselves as well as above us. He rules us by liberating us and raising us to union with Himself *from within*. And in so doing He liberates us from our dependence on created things outside us." (*The Inner Experience*, 52)

CHAPTER 2

Finding a Home in Nature

AFTER MERTON ENTERED THE MONASTERY at Gethsemani, the
external terrain continued to attract and shape his imagination. He was
often assigned to work in the fields, cutting corn or hay. There he exulted
in the changing light behind the Kentucky knobs that dotted the horizon,
writing poems ("Trappists, Working") about the "holy sonnets" sung by the
monks' saws as they felled trees in the upland (CP 96). Within the monas-
tery cloister he discovered favorite gardens and walkways that inspired him
to prayerful reflection. But there were intellectual and spiritual landscapes
to be explored as well.

Merton's early monastic training exposed him to the thinking of great
theologians, a reading practice he continued throughout his life. He studied
the writings of the Western and Eastern church fathers, steeping himself in
Augustine, Thomas Aquinas, and Bernard of Clairvaux. From them he
learned more about the beauty and value of nature. He embraced their
vision. Augustine, who, like Merton, came late to an understanding of
Christianity and the immanence of God, celebrated the God within himself
and all creation. Aquinas taught that all creation is holy. Bernard even went
so far as to counsel his monks to learn from nature: "You will find some-
thing more in woods than in books. Trees and stones will teach you that
which you can never learn from masters."[1] From the Greek church fathers
Merton received consolation and affirmation that the glory of God is
revealed in all creation.

Merton also read deeply and widely in philosophy, literature, poetry,
and anthropology. He was quick to recognize the similarity between the
French philosopher Merleau-Ponty and Zen—especially his view that com-
plete separation from one's environment is a delusion. Merton understood
that "I am inevitably a dialogue with my surroundings, and have no choice,

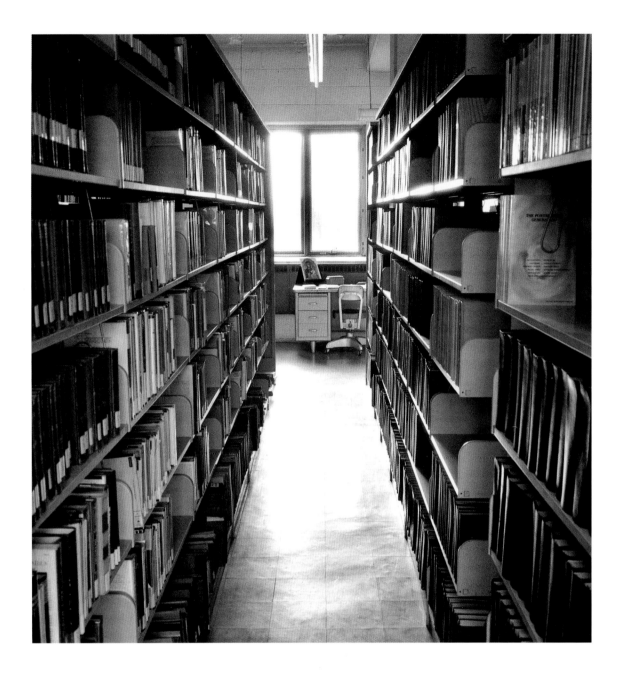

LIGHT STREAMS INTO THE MONKS' LIBRARY *Photo #*MF 36-05

"The new library was formally opened in the former brothers' novitiate building on Sunday, my birthday. I was very happy with it. The stacks are well lighted, a big pleasant room with desks was formerly a dormitory, and the reading room upstairs is pleasant too." (*A Vow of Conversation,* February 4, 1965)

A QUIET CORNER IN THE SCRIPTORIUM *Photo #*MF 55-02

GREEK BOOKS IN THE
MONKS' LIBRARY
Photo #35-40-13

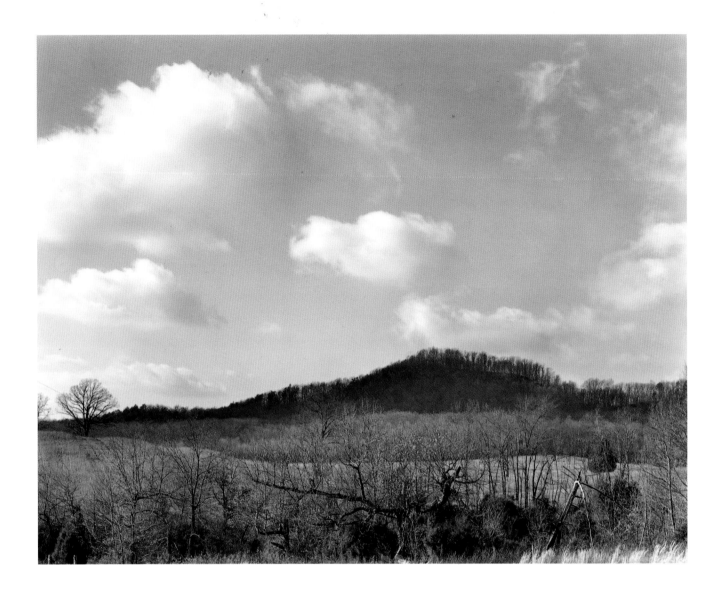

VINEYARD KNOB VIEWED FROM BEHIND THE DAIRY BARN *Photo #LF17*

"Beloved Spirit . . .

.

Enfold our lives forever in the compass of Your peaceful hills."

("A Whitsun Canticle," *Collected Poems*, 121)

though I can perhaps change the surroundings." To this journal note he added a passage in French that sounds strikingly like an Eastern koan: "L'intérieur et l'extérieur sont inséparables. Le monde est font au dedans et je suis tous hors de moi [The interior and the exterior are inseparable. The world is created from within and I am always outside myself.]" (DWL 48). In addition, Merton read the works of spiritual mystics like Julian of Norwich, who saw the love of God sustaining the tiny hazelnut, and Meister Eckhart, who described creation as an act of God's passion, simmering and boiling over in its immense diversity.

Perhaps central to Merton's spiritual growth was his practice of living the spirit of sacred scripture, especially the Hebrew psalms. Called by the monastery bell from his work or private prayer, seven times a day Brother Louis (as he was known in the monastery) gathered in the chapel with his fellow monks to chant praises to God. Following rich and ancient psalm tones, he sang of the God of creation: the God who feeds us with the finest wheat (Psalm 81), who leads us to green pastures (Psalm 23), who garments the hills with flocks (Psalm 65), who gives the sparrow a home and builds a nest for the swallow in which to put her young (Psalm 84). He praised the God about whom the psalmist is moved to exclaim: "Let everything that has breath praise the Lord" (Psalm 150).

As a Trappist monk bound by the Rule of Saint Benedict, Merton also steeped himself in Benedictine spirituality, a tradition that fosters a balance of study, worship, and manual labor. Benedict, the sixth-century father of Western monasticism, wrote a *Rule* for his monks to guide them toward the spiritual secrets that he had already discovered. Listening was a key virtue—listening for the voice of God in scripture, in the abbot, in the stranger at the door, and in one's personal prayer. Long periods of silence—given over to prayer, study, and work—are necessary to sharpen the monk's listening skills. Work for the Benedictine is never merely manual labor to support one's existence but rather a part of the monk's commitment to finding the holy in the ordinary. There is power in the seed and rhythm in the seasons to be discovered and reverenced. Interacting with this power and rhythm through agriculture is, for the Benedictine, just as prayerful as chanting psalms. Merton's love of nature enabled him to readily embrace this vision and even express it in writing. In *Gethsemani Magnificat,* a limited-edition photo-essay commemorating the centennial of the founding of the monastery, Merton anonymously wrote the following accompanying text to celebrate the physical and spiritual cycles of fertility: "The monk's life moves with the slow and peaceful rhythm of the seasons. The liturgical year is in harmony with the life cycle of growing things. . . . A soul that

matures in humble toil in fields, barns, and woods soon develops a beautiful and mellow spirituality, something simple and indefinable. . . . Christ lives close to the soil and His Apostles were men who grew up in the midst of nature."[2] This same attention to the rhythm of nature is evident throughout Merton's journals, where multiple references to working in the fields, clearing brush, and cutting and planting trees are seen not only as healthy work but also as moments that support and nourish prayer. Merton valued "cutting corn in the middle bottom. . . . It was good. That side of Trappist life is very good. All of it is good, but the cornfield side is good for *me*" (SS 18).

After almost eight years in the monastery, Merton was offered a singular grace. Most monks at Gethsemani were prohibited from stepping outside the monastery's walls except for specific, assigned work periods. On June 27, 1949, Merton's abbot, Dom James Fox, granted him permission to go beyond the monastery cloister to pray anywhere on their expansive property. Once beyond the monastery walls, Merton's heart soared. Here was a freedom akin to the carefree holidays of 1926 and 1927 when he had stayed in Murat, France, with the Privat family (SSM 55–59). In those years his father was painting in the Auvergne district and later in Paris. Young Tom, meanwhile, was discovering the delights of simple and unconditional family love and the freedom to run wild in the woods and the mountains. In such a happy venue Merton's childhood loneliness was somewhat assuaged and his infant excitement with nature was reawakened and nourished. The hills and woods of Murat became Merton's best companions. Now, years later at Gethsemani, he was again free to roam the fields and hills, to explore the ponds and valleys of his beloved countryside. He spent every free moment investigating the new expansiveness of his world. Each season offered its particular shapes, colors, and nuances of sound. Merton exulted in prayer time, walking under a canopy of trees or gazing over the panoply of knobs and fields visible against the horizon. Strolling along the road beyond the barns and new monastery buildings, Merton was keenly aware of the delight that overpowered him "from head to foot" and the peace that "smile[d] even in the marrow of [his] bones" (ES 419).

June 27, 1949, was indeed a pivotal moment in Merton's life. Particular geographies fed his imagination, offered him their color, formed in him shades of light and dark. Extended times of silence allowed nature to speak with subtle and vibrant voices, thereby shaping his heart. Merton's enjoyment of every created thing became part of his theological and personal reflection, finding its way into his prose and poetry with increasing frequency. Immersing himself in nature became part of Merton's daily routine. His writing after this date testified to the changes occurring deep within: it exhibited a new "expansiveness and depth," revealing how

A VIEW OF THE MONASTERY FROM VINEYARD KNOB *Photo* #MF45-08

"I got permission to take him [Laughlin] for a walk outside the enclosure, as if we were just going to stand on the hill behind Nally's and look at the view, but in the end we went all the way out to the top of the knobs, behind the lake. I did not know they were so steep. We seemed to be high and looking right down on top of the monastery, although we couldn't see it much because of the trees. We sat on the top where there was a fine view across the valley."
(*The Sign of Jonas*, October 31, 1948)

A SPRING DAY IN THE WOODS AT HANEKAMP'S *Photo #*MF 53-05

"Walk in the woods and be witnesses,

You, the best of these poor children."

("The Messenger," *Collected Poems*, 32)

CLOUDS ABOVE SAINT EDMUND'S FIELD *Photo #*MF 57-03

"Now my whole life is this—to keep unencumbered. The wind owns the fields where I walk and I own nothing and am owned by nothing and I shall never even be forgotten because no one will ever discover me. This is to me a source of immense confidence. My Mass this morning was transfigured by this independence." (*The Sign of Jonas,* December 22, 1949)

thoroughly his thinking and praying were being transformed. Merton was now able to go "beyond a past mental and physical confinement" to experience new horizons of contemplation (ES 328, n. 43).

One of Merton's favorite escapes for prayer was the attic of the garden house, with its broken window overlooking a valley. Here, in silence, Merton could inhale the smells and imbibe the sights he had come to see as necessary for meditation. He loved the "green grass" and allowed the "tortured gestures of the apple trees" to become part of his prayer. Moreover, he could learn valuable spiritual lessons from what he witnessed in nature. Meditating in the garden house one evening, Merton's prayer was disturbed by the growing tension among the crows, starlings, and circling buzzards, who were reacting to an eagle intruding into their territory. Suddenly, without warning, a hawk plummeted from the sky in "lightning flight, straight as an arrow," to snatch an unsuspecting starling. The event was for Merton a "terrible and yet beautiful thing." His praise was for the bullet-like accuracy of the hawk, honing his hunting skills through repetition and an all-consuming concentration. And *this* became the point of Merton's evening's prayer. He wished he could know his own business— monastic contemplation—as thoroughly as the hawk knew his. With a lyrical gesture of addressing the hawk as a soul mate "artist," Merton wondered if their two hearts could ever become one. Could hawk and man resonate with a single fulfilling purpose? Could the hawk's fulfillment in flying and capturing prey parallel Merton's fulfillment in being captured by the "thousand times more terrible" love of God? What a stunning moment of awe and spiritual understanding! Like Gerard Manley Hopkins's poetic tribute in "The Windhover," Merton's own heart also "stirred in hiding to serve Christ" (ES 407–8).

Merton's account of this episode was not merely a chronicle of an unusual event in the woods. Rather, Merton was beginning to realize how much his vision was expanding. Observing and reflecting on the interaction of nature, he was discovering a new motivation for committing himself wholeheartedly to his vocation. The same passion and single-mindedness that prompted the hawk to act must be present in Merton if grace—offered daily—was to be recognized and welcomed. The key was awareness of all that existed around and within himself.

Merton's deeply rooted awareness of nature affected not only his human happiness but also his spiritual life. He began to develop what natural-history writers call a "sense of place." No longer was Merton a dislocated orphan passing through this monastic experience to something else. He now relished an ever-deepening respect for his locale. One could say that Merton was transformed from casual traveler to dweller, anchored

A FENCE NEAR THE DAIRY BARN ON AN EARLY FALL DAY *Photo #MF29-02*

"Yesterday (cloudy and cool, quiet afternoon) I went out to the little woods by St. Malachy's field."

(*Dancing in the Water of Life,* August 16, 1964)

in his newfound paradise—the Abbey of Gethsemani. Merton's acute awareness of colors, shapes, sounds, and smells allowed him not just to see but to *see more*. His native alertness—traceable to his childhood and now buttressed by his developing practice of contemplation—became the catalyst for a deeper relationship with the physical world around him, and for discovering meaning in that world.

Like native peoples who live according to the rhythm of the landscape, Merton understood that "place" is not a static entity but rather a dynamic one. It is an event, an experience that not only molds personality but also helps to define one's identity and connects the soul with Being itself.[3] Merton recognized and embraced the transforming power of the Gethsemani landscape. Indeed, he had a history of embracing places that spoke to him and fed his imagination.

As a young lad living with his widowed father in Saint-Antonin, France, for the first time Merton experienced a slower-paced, more contemplative style of living. He remembered the majesty of that place in his autobiography. Surrounded by the ambiance of the Middle Ages, he experienced there the centrality of the Christian liturgy. The regular, periodic church bells and the geography of the streets "and of nature itself, the circling hills, the cliffs and trees, all focussed my attention upon the one, important central fact of the church and what it contained" (SSM 37). How significant that in these impressionable preadolescent years Merton was confronted by a "whole landscape, unified by the church and its heavenward spire," which seemed to proclaim a twofold purpose, namely, to glorify God and to remind humans of their ultimate purpose. In Saint-Antonin the landscape forced Merton to live as a "virtual contemplative" (SSM 37). There he experienced—even savored—his first taste of real belonging, a taste that later awakened in him an appetite for contemplation and the solitude of the hermitage. Merton believed that Saint Bonaventure College, nestled in the rolling hills of western New York State, was what he had been longing and searching for. But when he discovered the geography of the woods around the Trappist monastery in Kentucky, his *longing* evolved into a deeply felt sense of *belonging*.

Living at Gethsemani was for Merton a dynamic event, one that offered him daily affirmation of the connection his heart most desired. Once permitted to go beyond the monastic enclosure, Merton found himself in a lush Garden of Eden. He became acutely aware that he was no longer lonely and that the presence of God invaded him. With lyrical finesse celebrating the color, light, trees, creek, birds, and his deepened sense of the unconditional love of God, Merton often experienced his inner and outer geographies as one. Looking back at the tree-lined monastery against

PINE NEEDLES IN ICE AT THE EDGE OF DOM FREDERIC'S LAKE *Photo #MF37-10*

"Year ending. Yesterday I was looking at Dom Frederic's lake with thin melting ice all over it and a screen of pine needles along the back and the blue warm clearing sky above it and was thinking of all that had happened this year. Crazy but good year anyway." (*Learning to Love,* December 29, 1966)

an ever-darkening and thunderous sky, Merton understood deeply that "it is important to know where you are put on the face of the earth." He realized that nothing, not even the approaching storm, "could make that glen less wonderful, less peaceful, less of a house of joy" (ES 329–30).

Embedded in Merton's rapture at this sense of homecoming were not only echoes of his beloved France but also the first hint of Merton's desire for a hermitage. Although he eventually dismissed his daydream of a Carmelite "Desert" in the Kentucky valley as inconsistent with Cistercian life, Merton recognized that all he had "tasted in solitude" resonated with his monastic vocation. He believed his freedom to explore the monastery grounds had a "luminously intelligible connection with the Mass." He chose to see himself as a monk in nature, wondering if he could become a priest of the woods and daily "put all nature on my paten in the morning and praise God more explicitly with the birds" (ES 331).

Merton was not only glorying in this landscape and experiencing a deep sense of belonging; he was also beginning an inner journey that would lead to a new geography—the as yet unsuspected path of a solitude that embraced the whole world with compassion. Merton was embarking on what Ronald Knox had called a "spiritual Aeneid"—coming home to a place you have never been before—one that combines all you valued in the old home with added promises of a future that is new.

Merton continued to discover his own special places on the monastery grounds. He connected the majesty and mystery of external nature with that of his own expanding inner landscape. Certain key places helped Merton understand how God was speaking to him in his natural surroundings, and how he needed to let God find him when and where God chose. On New Year's Day 1950 Merton donned a raincoat and went out into the stormy woods to look at the "splendidly serious" landscape. Without much forethought, he "found [him]self climbing the steepest of the knobs" on the monastery grounds. He could see the forest beyond this knob, the wooded ridges trailing off in all directions, and the storm approaching from the southwest. Sheets of rain were being driven sideways by the wind—a combination Merton loved because of the "strength of [the] woods in this bleak weather." Alone and acutely aware of both the terror and the awesome beauty of the landscape, Merton was engulfed in what the British Romantic poets called an experience of "the sublime." There, at the summit of the knob, in the swirling, darkening elements, Merton believed that he was being called to a desert experience—to do battle with the wilderness devils. Disappointment engulfed him when the struggle did not unfold. His arduous climb had probably been for nothing. However, while descending the knob in the driving rain, Merton was

DEADFALLS IN THE WOODS NEAR THE HERMITAGE *Photo #*MF18-12

"All this is the geographical unconscious of my hermitage. Out in front the 'conscious mind,' the ordered fields, the wide valley, tame woods. Behind, the 'unconscious'—this lush tangle of life and death, full of danger, yet where beautiful beings move, the deer, and where there is a spring of sweet, pure water—buried!" (*Dancing in the Water of Life,* April 3, 1965)

AN OAK TREE AND MAY APPLES NEAR SAINT EDMUND'S FIELD *Photo #LF22*

"Yesterday was perfect. Went for a walk in the warm sun and strong, cool
wind down to one of my corners, a little spot at the edge of the wood by
St. Edmund's field, and there walked up and down with simple hesychastic
resolutions taking deeper shape in me." (*Learning to Love,* March 20, 1966)

A GATE AND WALKING STICKS IN THE CORNER OF THE ENCLOSURE WALL *Photo #LF02*

"Yesterday [Feast of] St. John's. I took a long walk in the knobs, even climbed the high one in the middle which I think is called Thabor, and followed the logging trail all along the top of McGuinty's hollow, out over the edge unto the hollow behind Donahue's. Woods dark, windy, and cold." (*Learning to Love,* December 28, 1966)

A HAWK FEATHER LIES ON THE ROAD TO McGUINTY'S HOLLOW *Photo #35-61-19*

THE WOODS BEYOND SAINT MALACHY'S FIELD *Photo #MF07-05*

"Reverend Father has given me this wood as a refuge for my scholastics. It is a pleasant place, and one can more quickly find solitude there than in the forest, which is further away. And so I find that now I spend more time praying and less time walking." (*Entering the Silence*, June 13, 1951)

surprised to discover halfway down a "bower God had prepared for me. . . .
It had been designed especially for this moment. There was a tree stump, in
an even place. It was dry and a small cedar arched over it, like a green tent,
forming an alcove. There I sat in silence and loved the wind in the forest
and listened for a good while to God. . . . The peace of the woods steals
over me when I am at prayer" (ES 393–94).

How understandable that Merton's initial choice of a privileged place
at the top of the hill was not God's choice. How clear that Merton's human
expectation of confronting the devil was not God's agenda. Merton was not
stalking an animal or a spiritual experience. Rather, God was stalking
Merton. They found each other, not atop the knob but on the side of the
hill in a *bower*—a word in English literary history that is rich with connota-
tions of intimacy. This sacred space became an intimate experience in
which Merton—the local exile wandering in the woods, as well as the
contemplative at home everywhere with God—met the God of surprises.
Not until he came upon the smooth tree stump in a sheltered bower did
Merton realize that God was already there, waiting to speak to him in the
wind, and offering an experience not only of contemplation but also of
communion.

As Merton allowed himself to be drawn deeper and deeper into his
vocation, he longed for more solitude in his life. The abbot first allowed
Merton to write in a little-used rare-books vault within the monastery,
away from the traffic and hubbub of the community. However, in 1952
Merton was again moody and restless. He believed he should transfer to a
community that could provide more solitude. So the abbot offered Merton
refuge in a discarded tool shed that had been tucked into the woods. Now
an unused ruin, this black and white painted building became for Merton
an extension of his black and white Cistercian habit, a cloistered "rampart"
midway between the monastery and the "great wilderness of silence" he
desired. Merton christened his tool shed hermitage "St. Anne's" (or St.
Ann's, as he sometimes spelled it). Here he enjoyed the view of the hills,
the corn fields, the crows in the cedars, and the expansive sky. With its
"doorway wide open to the sky," St. Anne's became for Merton a symbol
of the unity of all countries that shared the same sky (SS 29–30, 32).

Here Merton remembered how, newly orphaned at age sixteen, he
had walked the countryside of Sussex, England, looking for something he
could not name. At the top of Brooke Hill, a short walk from his school
buildings at Oakham, Merton could be by himself, "not waiting for any-
thing or looking for anything or expecting anything, but simply looking
out over the wide valley, and watching the changes of the light across the
hills, and watching the changes of the sky." Here the young Merton found

TANGLED WOODS NEAR SAINT MALACHY'S FIELD *Photo #MF12-11*

"Walk to us, Jesus, through the wall of trees,

. .

Still teach Your children in the busy forest,

And let some little sunlight reach us."

("Trappists, Working," *Collected Poems*, 96)

solace in the contours of the land, the expansiveness of the sky, and engaged in long periods of reflection. Merton recreated those soul-stirring sunsets against that winter sky in his unpublished novel "The Straits of Dover": "The sky would get streaked with slate colored clouds, and the west would fill with a soft pale crimson haze, with the sun a diffuse, red blur in the middle of it, hanging there for a long time, while the valleys darkened, and smoke spread flat over the frosty thatch of the villages, and the trees held their bare branches utterly still in the cold and silent air. Then you would walk home into the darkness of the valley, with your footsteps ringing loudly before you on the stony road."[4]

The resemblance of the monastery wilderness to the English country-side led Merton to believe that St. Anne's was "what I have been waiting for and looking for all my life." In the great silence of the pristine woods, Merton once again "found his place in the scheme of things." There was no need to look further. The "quiet landscape of St. Anne's," he confided, was making him well (SS 32).

In this place of grace Merton was a "priest with all the world as [his] parish," his morning Mass continuing in his day of thanksgiving, work, and worship (SS 33). Here he could enjoy nature redolent with smells, sounds, and color. He could watch the red-shouldered hawk slowly soaring over Newton's farm, "tracing out a circle of silence in the sky," and view flocks of migrating birds, dazzling in the sunlight like a "school of fish" with fins of red and orange (SS 181, 34). Here Merton could spend long hours of contemplation, engendering the insight and linguistic imagery for *Thoughts in Solitude.* And here, several years later, he would sketch out his now famous description of crossing the busy intersection in downtown Louisville at Fourth and Walnut (renamed Mohammad Ali Boulevard). On that March day when Merton was in town for a medical appointment, he suddenly realized that he was united with all the people around him. Because they were not separate from each other, there could be no isolation from them. The possibility of a separate holy existence within a monastic enclosure was an illusion. With linguistic exuberance Merton suddenly realized how much he loved all those people. He rejoiced in being a man like everyone else, yet one whose solitude created a responsibility for his brothers and sisters, "all walking around shining like the sun" (CGB 141).

THE AVENUE OF TREES AT THE ABBEY ENTRANCE *Photo #MF 27-01*

"The pilgrim moon . . .

.

. . . departs, up the long avenue of trees."

("The Trappist Abbey: Matins," *Collected Poems*, 45)

THE FRONT LAWN OF THE ABBEY IN HEAVY FOG *Photo #*MF 27-03

"When this valley was

Made out of fresh air

You spoke my name

In naming Your silence."

("O Sweet Irrational Worship," *Collected Poems*, 344)

CUMULUS CLOUDS FLOATING ABOVE VINEYARD KNOB *Photo #*MF 13-04

"Behold the fertile clouds, in golden fleets,

Like flying frigates, full of gifts."

("A Whitsun Canticle," *Collected Poems*, 119)

CLOUDS ABOVE THE HILL BEHIND NALLY'S *Photo #MF46-04*

"Yet doors of sanitary winds lie open in the clouds

To vistas of those laundries where the clean saints dwell."

("On a Day in August," *Collected Poems*, 205)

A COLD WINTER RAIN SWEEPS OVER THE KNOBS *Photo #*MF 52-10

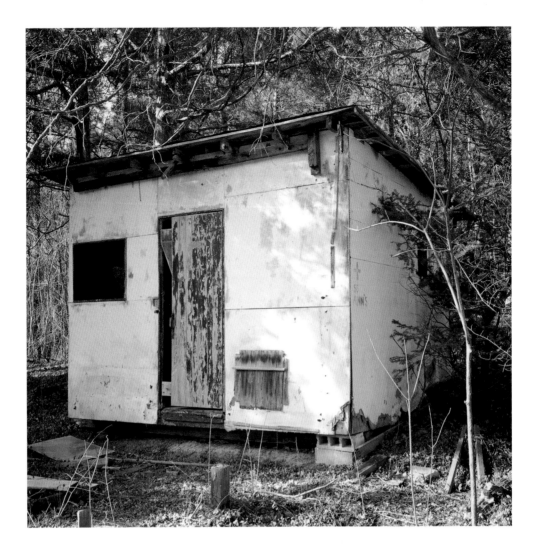

A FRONT VIEW OF MERTON'S TOOL SHED HERMITAGE *Photo #MF03-03*

"I am now almost completely convinced that I am only really a monk when I am alone in the old toolshed Reverend Father gave me. (It is back in the woods beyond the horse pasture where Bro. Aelred hauled it with the traxcavator the day before Trinity Sunday.) True, I have the will of a monk in the community. But I have the *prayer* of a monk in the silence of the woods and the toolshed. To begin with: the place is simple, and really poor with the bare poverty I need worse than any other medicine and which I never seem to get. And silent. And inactive—materially. Therefore the Spirit is busy here." (*A Search for Solitude,* September 3, 1952)

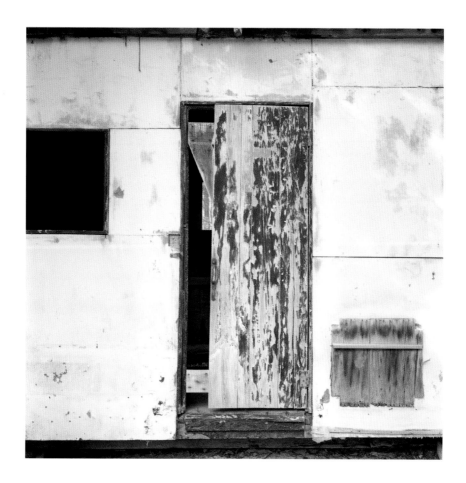

THE REMAINS OF THE FRONT WALL, DOOR, AND WINDOW AT ST. ANNE'S
Photo #MF03-04

"How many graces, here in St. Anne's, that I did not know about, in those years when I was here all the time, when I had what I most wanted and never really knew it. Which only shows that solitude alone was not exactly what I wanted. How rich for me has been the silence of this little house which is nothing more than a toolshed—behind [which] on the hillside for two years they have tried without success to start a rock garden." (*A Search for Solitude,* March 19, 1958)

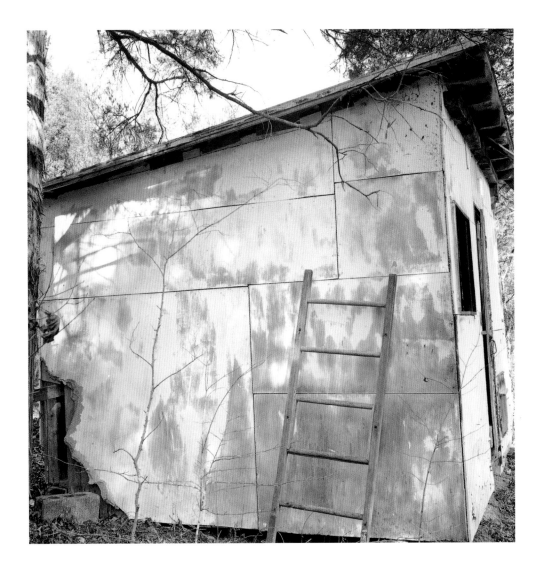

A SIDE VIEW OF ST. ANNE'S *Photo #MF03-06*

"Silence is louder than a cyclone

In the rude door, my shelter."

("Song," *Collected Poems*, 197)

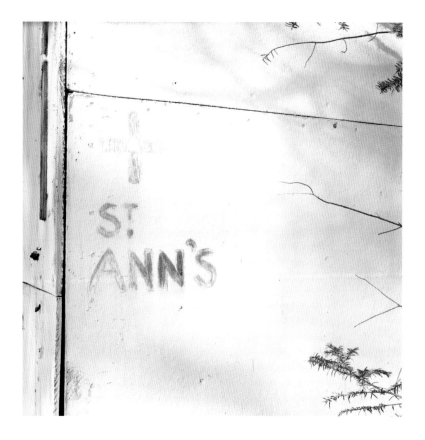

"Looking at the crucifix on the white wall at St. Anne's . . . over-
whelmed at the realization that I am a *priest*, that it has been given
to me to know something of what the Cross means . . . that St.
Anne's is a special part of my priestly vocation: the silence, the
woods, the sunlight, the shadows, the picture of Jesus, Our Lady of
Cobre and the little angels in Angelico's paradise." (*A Search for
Solitude,* February 17, 1953)

A LADDER LEANING AGAINST THE WALL AT ST. ANNE'S *Photo #MF06-11*

"It seems to me that St. Anne's is what I have been waiting for and looking for all my life and now I have stumbled into quite by accident. Now, for the first time, I am aware of what happens to a man who has really found his place in the scheme of things. . . . In the silence of St. Anne's everything has come together in unity and the unity is not my unity but Yours, O Father of Peace." (*A Search for Solitude,* February 16, 1953)

ST. ANNE'S INTERIOR IN AFTERNOON LIGHT *Photo* #MF06-07

"What is easier than to discuss mutually with You, O God, the three crows that flew by in the sun with light flashing on their rubber wings? Or the sunlight coming quietly through the cracks in the boards? Or the crickets in the grass?" (*A Search for Solitude,* September 3, 1952)

A SMALL POND NEAR ST. ANNE'S *Photo #MF05-11*

"Ponds full of sky and stillnesses

What heavy summer songs still sleep

Under the tawny rushes at your brim?"

("The Sowing of Meanings," *Collected Poems*, 188)

CHAPTER 3

Seeing Paradise with the Heart

IT IS SAFE TO SAY that the more silence and solitude Merton experienced, the more he craved. Prayer, etched deeply into his daily routine, was inscribed in the innermost recesses of his heart. In the mid 1950s Merton found quiet moments in a derelict trailer in the woods where he could listen to the wind in the trees and the creatures stirring nearby. In this rusted metal chapel, which he regarded as an entrance to paradise, Merton heard the Holy One calling him "friend" and "son." He felt the sleeping seed of prayer awaken. So powerful were these periods of communion during which he could explore his inner geography that Merton memorialized this makeshift hermitage in one of his best poems, "Elias—Variations on a Theme" (CP 239). Yet he continued to hunger for more frequent and more sustained opportunities for communion with the divine.

Such an opportunity presented itself in 1960 with the building of a simple cinderblock house less than a mile from the main monastery buildings. The Cistercian community considered this a retreat house for ecumenical dialogue; Merton, however, envisioned a hermitage for himself. The two-room structure, built on the crest of Mount Olivet and named by Merton "Saint Mary of Carmel," offered a view of the woods behind and the spreading valley before him. After ten years of dreaming about a hermitage and finally gaining permission to spend time here, Merton frequently commented in his journal what a difference Saint Mary of Carmel had made in his prayer life. Perhaps the wood smoke reminded him of the houses in Saint-Antonin, France, where his father desired to build a home for his family. Now son Tom had his own little *casa* in which to read, meditate, observe nature, and enjoy the solitude.[1] Describing the trees visible in all directions from his vantage point on the hermitage porch, Merton recreated in lyrical phrases the feeling of the place, noting with satisfaction

THE RUSTING RED TRAILER, ONCE USED BY MERTON AS A HERMITAGE, AT THE EDGE OF THE WOODS *Photo #MF64-11*

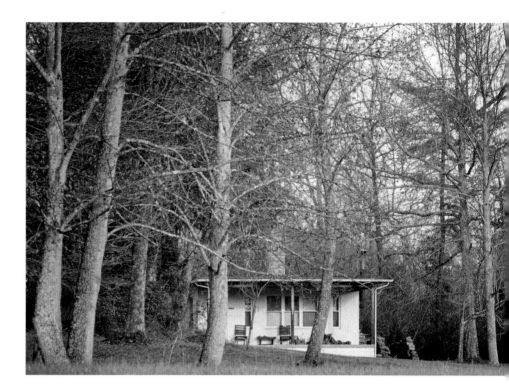

A VIEW OF THE HERMITAGE AMID ITS SHELTERING TREES *Photo #35-61-05*

"Everything about this hermitage simply fills me with joy. There are lots of things that could have been far more perfect one way or the other—ascetically, or 'domestically.' But it is the place God has given me after so much prayer and longing—but without my deserving it—and it is a delight. I can imagine no other joy on earth than to have such a place and to be at peace in, to live in silence, to think and write, to listen to the wind and to all the voices of the wood, to live in the shadow of the big cedar cross, to prepare for my death and my exodus to the heavenly country, to love my brothers and all people, and to pray for the whole world and for peace and good sense among men. So it is 'my place' in the scheme of things, and that is sufficient!" (*Dancing in the Water of Life,* February 24, 1965)

SCREEN DOOR, BENCH, AND WINDOW AT THE HERMITAGE *Photo #MF03-09*

A WAGON WHEEL AT THE FOOT OF THE CROSS AT THE HERMITAGE *Photo* #MF23-04

that here was "Real silence. Real solitude. Peace." Here the trees cooperated with "a great dance of sky overhead" (TTW 73).

During periods of uninterrupted silence, Merton could walk barefoot in the woods, discovering the "hidden wholeness" in creation around him.[2] He could relish the present moment, delighting in the wind suddenly gusting over the knobs, the graceful flower bending in prayer on its long stem, or the vociferous crows nattering about some affront to their assumed dignity. On long, silent winter afternoons he could breathe the sharp air that supported periods of sustained prayer. He could generate new ideas for essays on the irresponsible use of nuclear weapons or the moral imperative of nonviolence and social justice; he could savor the fruits of his contemplative intuition for the updated *New Seeds of Contemplation*. Here, despite his perplexity about the state of the church and the world, he could find "peace in seeing the hills, the blue sky, the afternoon sun" (DWL 33–34).

The dynamic power of place and the rightness of his being there touched Merton deeply. The contours of the Kentucky hills, the woodland creatures, the morning sky, and the changing seasons offered up their poetry for reflection and prayer. For Merton the huge bullfrogs sang "like trains," the harvest sheaves became "liturgy," and the "creeping things," understanding the asceticism of winter, hastened to "end their private histories" in the solitude of a cocoon (CP 169, 174, 182). Merton's record of these intimate interactions presents us with a window into his heart. We begin to understand how the entire world is "secretly on fire" (CP 280) and how the dying light following vespers invited a "more mature and more complete solitude." Moreover, we see the scene through Merton's eyes: "The pines are tall and not low. There is frankly a house, demanding not attachment but responsibility. A silence for dedication and not for escape. Lit candles in the dusk. *Haec requies mea in saeculum saeculi* [This is my resting place forever]—the sense of a journey ended, of wandering at an end. *The first time in my life* I ever really felt I had come home and that my waiting and looking were ended" (TTW 79–80).

As he roamed the hills and valleys, Merton's attraction to the ponds, lakes, and streams on the monastery property supported his prayer. He loved to meditate at the lake by Saint Bernard's field, with its "green ice and its dead trees and silences" (OSM 44), and he preferred reciting the psalms near the pond in the ravine that wound its way through the knobs toward Herman Hanekamp's house (DWL 168). Perhaps this pond became for Merton the epitome of Psalm 23: God's restful waters beside green pastures to revive his drooping spirit. Surely he experienced how his cup was overflowing. Or perhaps this pond was embodied in his poem "Stranger," celebrating the moment of poise when the "vast Light" reveals the true self

FURROWED TREE TRUNKS AT THE HERMITAGE *Photo* #MF18-04

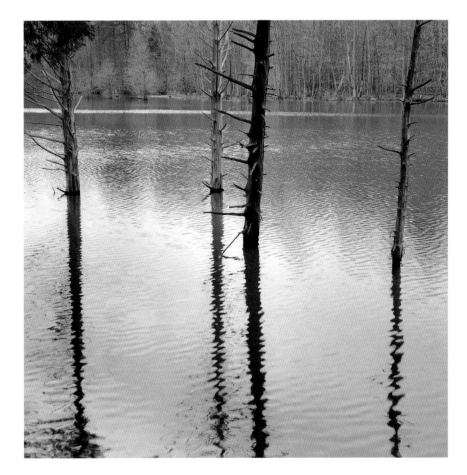

REFLECTIONS OF CEDAR TREES
AT SAINT EDMUND'S LAKE
*Photo #*MF09-02

"When no one listens

To the quiet trees

When no one notices

The sun in the pool

.

One bird sits still

Watching the work of God."

("Stranger," *Collected Poems*, 289–90)

DETAIL OF A MAPLE TREE
ON THE FRONT LAWN OF
THE HERMITAGE
*Photo #*MF23-02

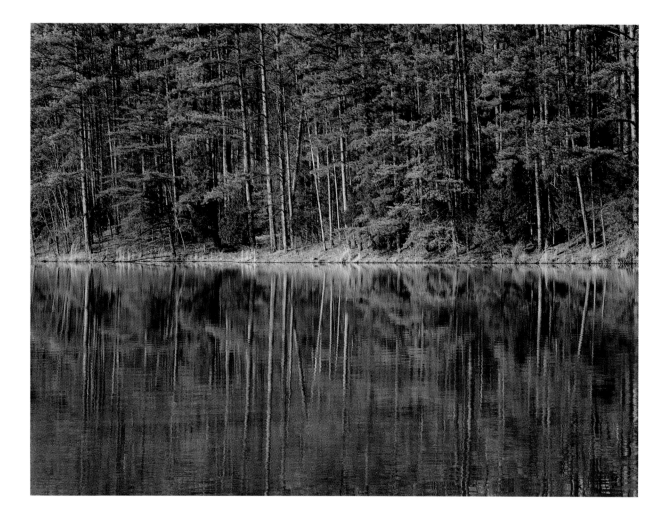

PINE TREE REFLECTIONS IN DOM FREDERIC'S LAKE *Photo #*MF12-09

"I went for a walk to the woods. These days 'to the woods' means—along the track by Dom Frederic's lake and around to the place of the Derby Day picnic—flat, steady, quiet and somehow very recollected full of awareness, peace—'holiness'—awe. A place of life in which both M. and God are more present and I remember His gift to me—her love—and the way that love (against all that the books say) seemed to bring me (and still does) closer to them." (*Learning to Love,* September 4, 1966)

in perfect clarity (CP 289). A brook near Saint Anne's, created by the early spring rains, fascinated Merton, as did the newly formed rivulets coursing in all directions (SS 37). On those rare sunny days in winter, Merton loved to watch the first hints of life stirring. With meadowlarks singing near "green watercress between banks of snow," Merton gazed at the intense blue of the lake, "very blue, and blinding with sun, along the edge of the sheet of melting ice, covered with snow" (SS 164).

After a foray into Edelin's pasturelands, Merton believed he had found the perfect place for a desert experience. He reveled in its beauty and seclusion, secretly hoping that the owner would bequeath this acreage to the monastery. Merton could envision five or six hermitages scattered on the hillsides. He could imagine how the springs and creeks within its enclosed valley of welcoming trees would foster the silence and deep prayer he longed for. If only the abbot would agree to study this project! Merton confided this cherished thought in his journal (DWL 147–48).

When Victor and Carolyn Hammer or poet friends came to visit, Merton enjoyed picnicking at the lake near Bardstown Road or the lakes behind Nally's. On hot summer days he often swam in one of the lakes far out on the monastery property, then lay shirtless on the grass, praying and allowing the sun to penetrate his aching shoulders. To celebrate the feast of Saint Francis Merton declared a holiday from his new routine of living full time in the hermitage. Early in the day he "walked through the hollow [and] then to the long field and in and out the wood where the deer sleep. In the afternoon took a long walk to Dom Frederic's Lake and around by St. Edmund's field to the shallow lake" (DWL 300–301). There he could escape the hassles of being a celebrated writer and relinquish all fear and worry. There the water and the refreshment it symbolized could work its magic.

It is small wonder that in 1968, when Merton determined to publish four issues of poetry and prose from both avant-garde and established writers, he chose the title *Monks Pond* for his magazine. The name functioned on several levels. Ponds were one of Merton's favorite landscapes. As self-contained ecosystems, they supported multiple and interdependent life forms. Usually small, they could also be ephemeral, drying up when the spring and summer rains withdrew—a perfect symbol for the diverse and short-lived project Merton had in mind. He was delighted to report in the introduction to the third issue that "the Pond is overflowing" with submissions, and again in the fourth and final issue, with a corresponding cover photo and introductory note, that "the Pond has frozen over" (MP 116, 212).

As Merton was savoring the new riches of his publishing effort, he was also discovering hidden ponds and watering holes unknown to the monastic community. In the southeast corner of Linton's farm Merton found a

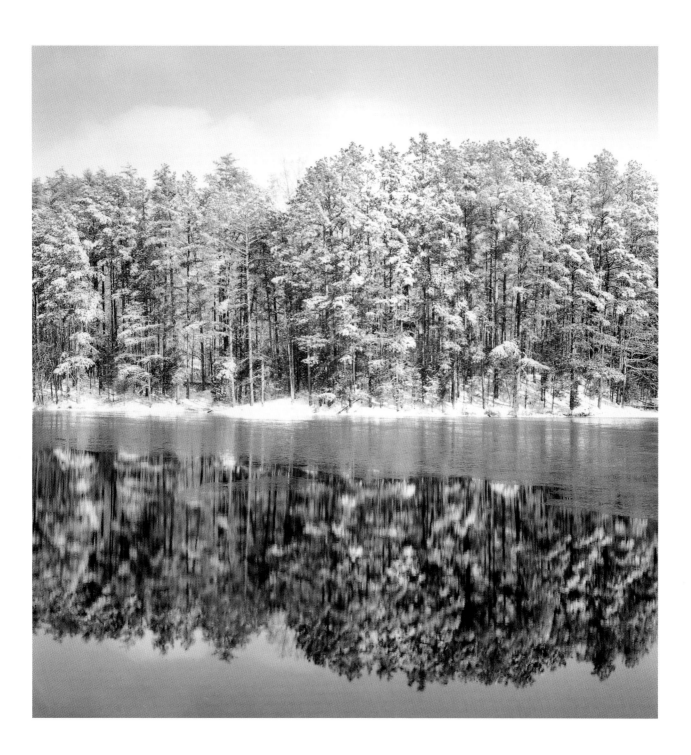

DOM FREDERIC'S LAKE AFTER A HEAVY SNOWFALL *Photo #*MF37-11

"The stormy weeks have all gone home like drunken hunters,

Leaving the gates of the grey world wide open to December."

("The Regret," *Collected Poems*, 33)

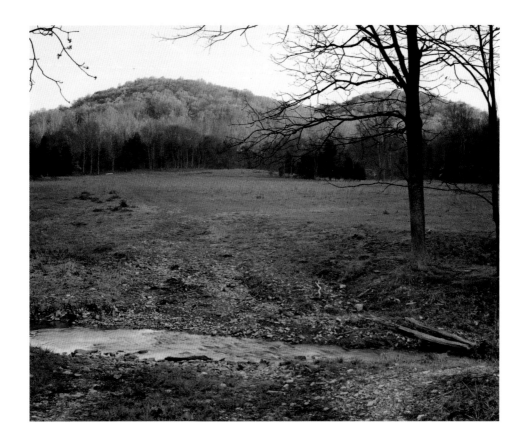

A PORTION OF THE VALLEY FLOOR AT EDELIN'S HOLLOW *Photo #*MF 56-02

"Yesterday was extraordinary. I had planned to take a whole day of recollection out in the hills around Edelin's hollow to explore the place and get some idea of where it goes and what is around it. Fortunately, Edelin came along with Brother Colman, who drove me out in the Scout, to show me where one could get into his property from the top of the hills on the west. It was wonderful wild country and I had a great day." (*A Vow of Conversation,* January 6, 1965)

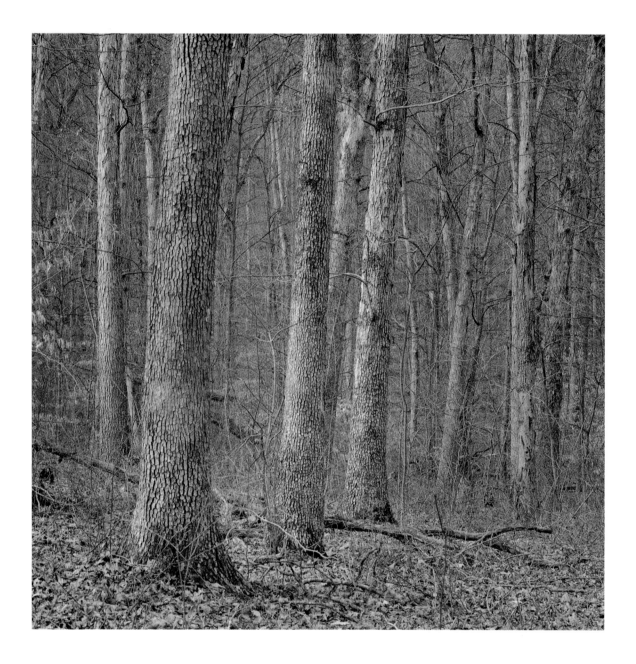

THE WOODS NEAR VINEYARD KNOB *Photo #*MF07-11

"To go out to walk slowly in this wood—this is a more important and significant means to under-

standing, at the moment, than a lot of analysis and a lot of reporting on the things 'of the spirit.'"

(*Learning to Love,* March 2, 1966)

new pond in a hollow sheltered from the stinging wind by "lots of rocks" and a "steep dip." There Merton prayed, watching the sun on the "pale green water," and staying "quiet in the sun . . . for a long time" (OSM 63, 66). These out-of-the-way places were more and more conducive to Merton's prayer and need for solitude. They called to him with a siren's song, just as the Têt River in southern France had first enticed him with its rippling music. There, so long ago, whenever Ruth Merton and her child went "on the bridge," Baby Tom "stood up in his pram, especially to see the river" (TB 3). Soon the waters of the Pacific would call Merton to new adventures and eternal rest. In his desire to blend the mysticism of East and West, he was determined to "listen at length to this Asian ocean" (OSM 100).

Near the ponds were Merton's beloved trees. Whether in crisp winter stillness, rain, or sparkling sunshine, Merton was grateful for his ability to pray while "walking up and down under the trees" (ES 36). Early in his monastic life Merton described his prayer out of doors as saturating the woods with psalms (ES 124). His practice of reciting the Divine Office in some of his favorite haunts in the nearby woods helped him connect these places with particular prayers. In his position as monastery forester, Merton spent hours evaluating the health of the trees on the monastery grounds and marking some for removal. In the early 1950s he requested and received from the U.S. government hundreds of loblolly pines that he and the novices planted on the hillsides to capture water runoff and prevent soil erosion. The intensity of his physical interaction with trees not only energized Merton because of the exercise it provided but also made him keenly aware of the transforming touch of nature on the inner landscape of his prayer and reflection (SJ 69, 201–2, 345). One could even say that when Merton went outside into nature, nature entered into him.

During Christmas 1952, for example, Merton realized that as he sang the Epiphany gospel at High Mass in the monastery chapel, the trees in the woods were present to his imagination. Earlier in the week he had practiced his chanting in the woods; now tune and tree were inextricably intertwined. Merton had even playfully constructed an answer to the biblical question: "Where is he that is born King of the Jews?" (Matt. 2:2). Merton knew and was delighted to proclaim aloud: "He and I live in the trees." As Merton wrote in his journal: "Thus it is that I live in the trees. I mark them with paint, and the woods cultivate me with their silences, and all day long even in choir and at Mass I seem to be in the forest: but my children [the scholastics] themselves are like trees, and they flourish all around me like the things that grow in the Bible" (ES 464–66).

Merton loved to ponder how the trees shaped his thinking, how they molded him with their silences. He loved the locusts, the pines, the tall firs,

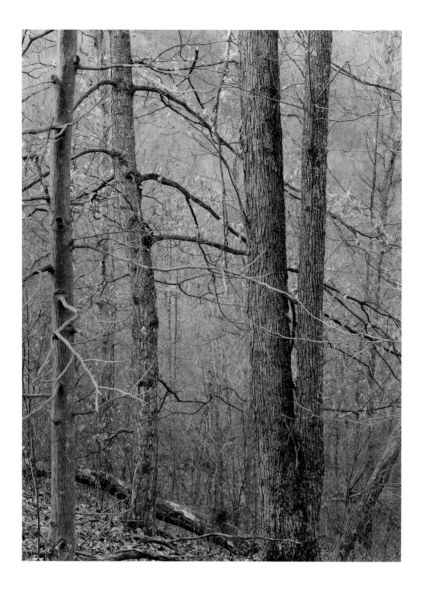

WINTERTIME NEAR THE TOP OF CROSS KNOB *Photo #LF13*

"It is the kind of day I like, and like Christmas to be too: dark, cloudy, windy, cold with light rain blowing now and then. I have had wonderful Christmases (Christmas weeks) here with this kind of winter weather, unforgettable. Days not too bad for walking out on the wooded knobs, cold and lonelier than ever and full of apparent meaning. They talk to me of my vocation."

(*Dancing in the Water of Life,* December 25, 1965)

the walnut, the black oaks, the wild cherries, the lindens, and when he was in California, the immense silent redwoods. He was caught by how the trees could hint of the coming spring, how the "wilderness shines with promise." And he saw light, water, stones, sky, tractor tracks, and waterfalls as his sisters and brothers, admitting almost sheepishly that he had never before spoken so intimately with nature. Surrounding him were "Mediterranean solitude," fond memories of Italy, and "the song of my Beloved beside the stream" (ES 412). The increasing frequency of nature references in Merton's writing and their connection to his prayer reveal how intensely being in the woods nourished Merton's vocation, and how unswervingly the God of Creation drew him toward more intense solitude in his final years.

Merton began to spend more time in the hermitage. Gradually he became aware of the deer that shared his woods. Once these graceful animals became accustomed to Merton's presence, they wandered more freely in the nearby clearing, often stopping to gaze at this lone monk. Curiosity and fascination seemed to be mutual. Merton, for his part, was entranced by these silent, mysterious creatures that thrive in the wilderness. Perhaps unknowingly the deer symbolized for Merton the silence he longed for. Perhaps they were an icon of the immanence of God and grace freely given. Or perhaps they formed a tableau of Psalm 42: "As the deer longs for running water, so my heart longs for you, O God." In any event, Merton was delighted by their unpredictable appearance, always welcoming whatever interaction might evolve. At first he watched the deer through field glasses, only to discover that the deer, too, were intently watching him. This was a "lovely moment" of looking that "stretched into ten minutes perhaps!" (DWL 189). Merton was captivated.

Merton's scientific observation of the deer quickly evolved into more lyrical and profound reverie. In a later encounter with two stags and two does, his fascination with their "beautiful running, grazing," was transformed into soul-stirring "contemplative intuition." Merton was able to see beyond the physical movement of the deer, to see with the heart. In a flash he understood something of the universal "deerness" captured by cave painters long ago who were sensitive to the "*Mantu* or 'spirit' shown in the running of the deer." Simultaneously he understood "something essential" about himself. In this poignant moment Merton moved from a solely outward glance at the external landscape to an inward glance at the spiritual meaning of creation and the geography of his own heart. Not only did he recognize a link with his human ancestors; he was aware also of the divine spark he and the deer shared with Being itself. As he later confided in his journal, it was no wonder he "longed to touch them" (DWL 291).

In the succeeding days Merton experienced a new intimacy with the

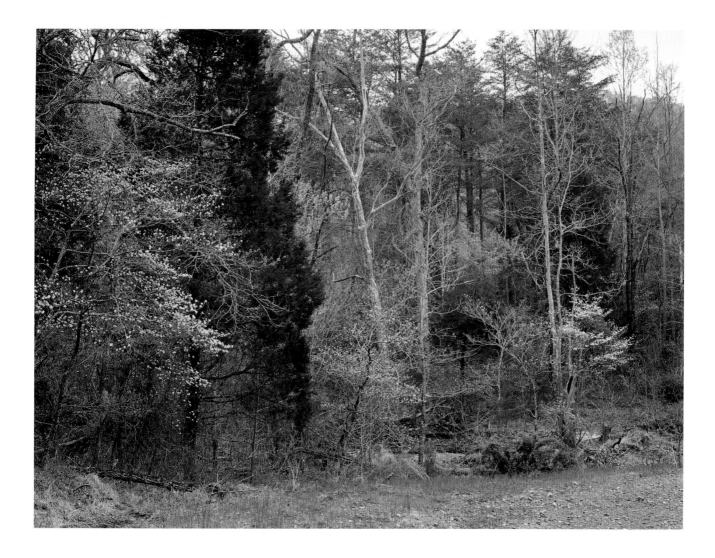

DOGWOOD BLOSSOMS IN THE WOODS AT HANEKAMP'S PLACE *Photo #MF53-09*

"The valley is dark and beautifully wet and you can almost see the grass growing and the leaves pushing out of the poplars. There are small flowers on my redbuds and the dogwood buds are beginning to swell. There is no question for me that my one job as monk is to live the hermit life in simple direct contact with nature, primitively, quietly, doing some writing, maintaining such contacts as are willed by God, and bearing witness to the value and goodness of simple things and ways, and loving God in it all." (*Dancing in the Water of Life,* April 15, 1965)

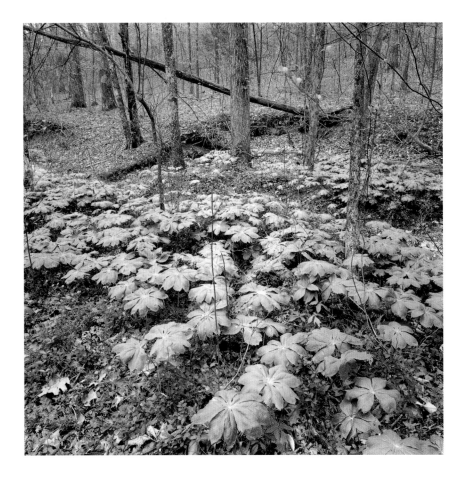

EARLY SPRING IN THE WOODS NEAR SAINT EDMUND'S LAKE *Photo #MF15-07*

"Dark day, colder. Andy Boone's buzz saw is going and it sounds like winter again. But the grass is very green, the redbuds show well against the green pines and the brush bursting into leaf, small wildflowers everywhere and the May apples opening their shiny new umbrellas." (*Learning to Love,* April 21, 1966)

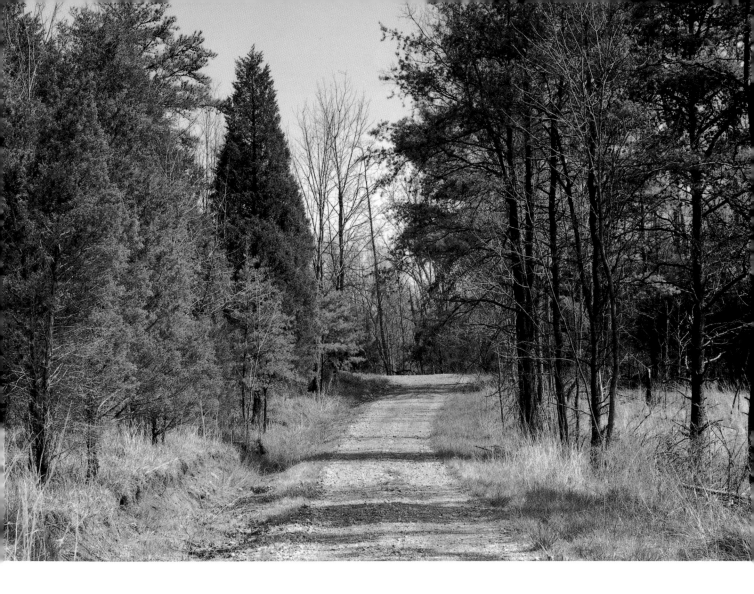

THE GRAVEL ROAD LEADING TO THE HERMITAGE *Photo #LF19*

"In the heat of noon I return through the cornfield, past the barn under the oaks, up the hill, under the pines, to the hot cabin. Larks rise out of the long grass singing. A bumblebee hums under the wide shady eaves." (*Dancing in the Water of Life,* May, 1965)

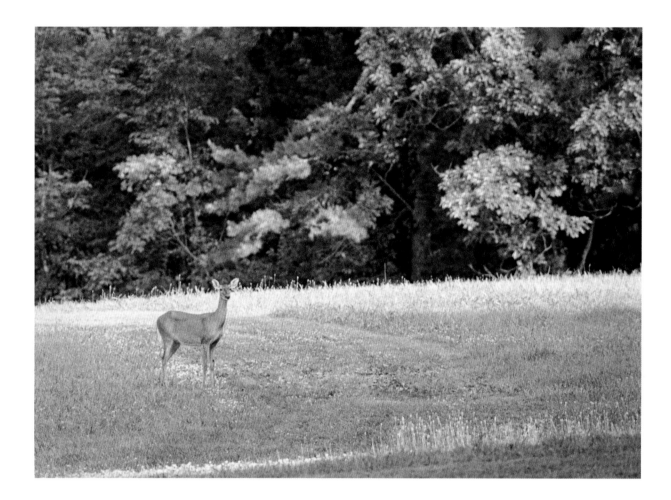

A SOLITARY DEER ON THE FRONT LAWN OF THE HERMITAGE *Photo #35-65-05*

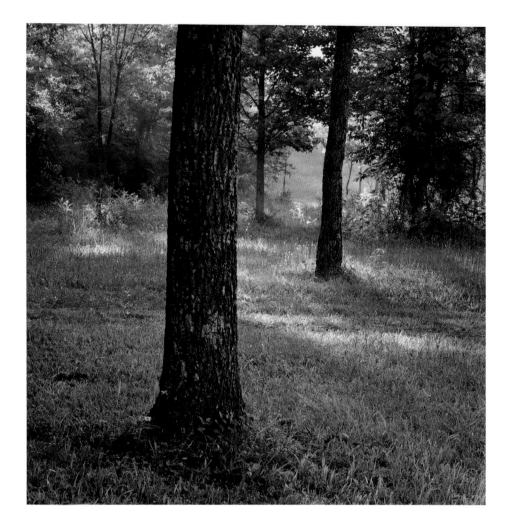

EARLY MORNING LIGHT STREAMING THROUGH THE TREES AT THE HERMITAGE
*Photo #*MF 17-07

"The great work of sunrise again today. The awful solemnity of it. The sacred-
ness. Unbearable without prayer and worship. I mean unbearable if you really
put everything else aside and see what is happening! Many, no doubt, are vaguely
aware that it is dawn: but they are protected from the solemnity of it by the
neutralizing worship of their own society, their own world, in which the sun no
longer rises and sets." (*Turning Toward the World,* May 31, 1961)

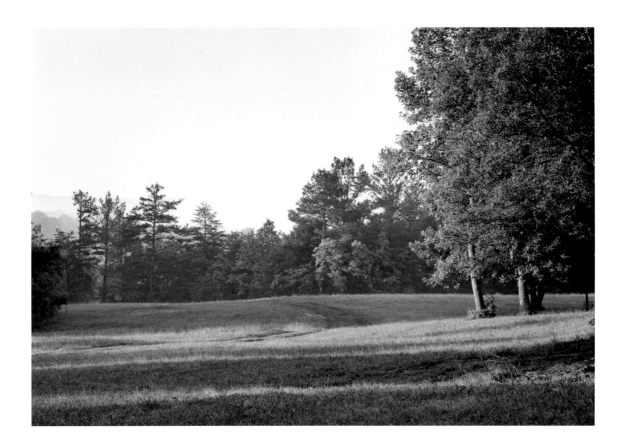

A VIEW LOOKING SOUTH FROM THE FRONT LAWN OF THE HERMITAGE *Photo #*MF 16-02

"Cool and lovely morning, clear sky, every changing freshness of the woods and valley! One has to be in the same place every day, watch the dawn from the same window or porch, hear the selfsame birds each morning to realize how inexhaustibly rich and diverse is this 'sameness.' The blessing of stability is not fully evident until you experience it in a hermitage." (*A Vow of Conversation,* May 28, 1965)

deer in the woods. One doe accepted his presence, even moving toward him as he paced to and fro in front of the hermitage at dusk, reciting Compline (DWL 292). On another occasion Merton spotted a wounded deer limping in the field. He found himself "weeping bitterly" at the sight. Yet the deer, after giving him a long look, "bounded off without any sign of trouble" (DWL 315–16). Could it be that the human and animal worlds were reaching across the chasm for some kind of deep, inexplicable communication? Certainly Merton was discovering how the natural world is embedded in mystery and God is also Mystery. He had once immortalized a deer thrashing in the monastery reservoir in a poem ("Merlin and the Deer") in which Merton/Merlin, the "gentle savage," awakens in order to weave a spell in the woods and release the deer back to its woodland freedom (CP 736). Delighting in these secrets of nature, Merton's subsequent encounters with deer revealed his concern for their safety during hunting season and their respite from hectoring dogs. A significant transformation had occurred. Merton's vision had broadened. Deer were no longer the "other" to be viewed through field glasses but fellow inhabitants of the woods who were worthy of his protection. Intimacy and communion with the deer had blossomed into compassion and responsibility for them.

Special times of the day also captured Merton's affection. He loved the predawn light with its promise of a new day. That promise—as he wrote in a 1946 poem ("After the Night Office—Gethsemani Abbey")—carried with it the surprising delight of commanding the sun to delay its arrival so that the "secret eye of faith" could savor its inner sight. Yet the sun, unruly and persistent, clothing the monastery buildings one by one, surprised Merton into realizing that he and they were "souls all soaked in grace" (CP 108). *Reading* that early-morning light seemed to reinforce Merton's inner joy. He exulted when the "dawn was as clear as glass and the whole white earth praised the Immaculate Mother of God" (RM 400). He loved to experience the sun "coming up and throwing soft mother-of-pearl high-lights on the frozen pastures of Olivet" (ES 405). Sunrise called forth "solemn music in the very depths" of his being and attuned his heart to the cosmos (TTW 292). Dawn was also a time of precious intimacy, partly because of the vastness of silence Merton experienced at the monastery and partly because of the virginal quality of newness breaking all around him. In those early hours he could experience the "full meaning" of Lauds—his morning prayer of praise—for this was the *point vierge* of the morning, the virgin point between darkness and light, between nonbeing and being when the valley came awake. Punctuating the deep silence of the night was the occasional "Om" of the bullfrog, then the tentative chirping of the waking birds, asking the Father if it was time to be (CGB

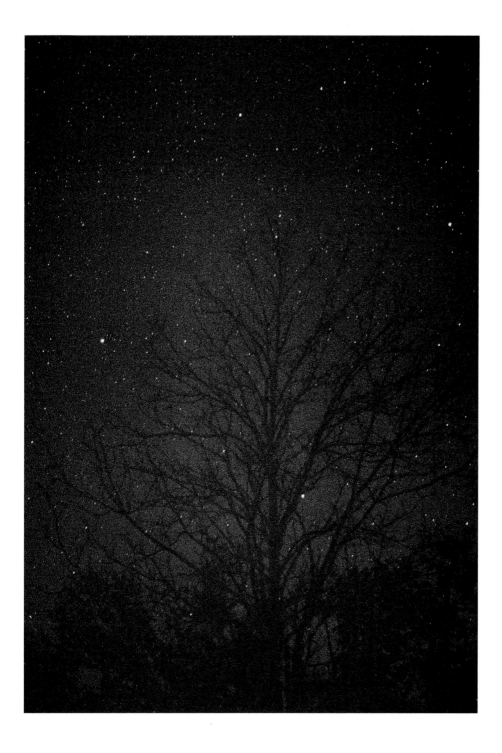

"And this morning, coming down, seeing the multitude of stars above the bare branches of the wood, I was suddenly hit, as it were, with the whole package of meaning of everything: that the immense mercy of God was upon me, that the Lord in infinite kindness had looked down on me and given me this vocation out of love, and that he had always intended this, and how foolish and trivial had been all my fears and twistings and desperation."

(*Dancing in the Water of Life,* December 9, 1964)

BARE TREES SILHOUETTED AGAINST
THE STARS OF A NIGHT SKY
Photo #35-59-09

117–18). At this dramatic moment of breaking day, Merton often experienced a deep unity with God and creation. The Canticle of Zachariah that Merton was reciting became part of his soulscape and experience of paradise: "Out of God's deepest mercy / A dawn will come from on high" (International Commission on English in the Liturgy translation, 1994).

Dawn's daily genesis never ceased to delight Merton and teach him about his own identity, namely, that he, too, contained a *point vierge* that was his access to the paradisiacal home he so longed for. Through his early-morning prayer Merton came to understand that at the core of his being was

> a point of nothingness which is untouched by sin and by illusion, a point of pure truth, a point or spark which belongs entirely to God. . . . This little point of nothingness and of *absolute poverty* is the pure glory of God in us. It is so to speak His name written in us, as our poverty, as our indigence, as our dependence, as our sonship. It is like a pure diamond, blazing with the invisible light of heaven. It is in everybody, and if we could see it we would see these billions of points of light coming together in the face and blaze of a sun that would make all the darkness and cruelty of life vanish completely. . . . I have no program for this seeing. It is only given. But the gate of heaven is everywhere (CGB 142).

In this sacramental vision of reality, each bird, each frog—and Merton himself—was continually created; moment to moment each creature was loved into being by a God who is intimately present to each species and each individual in that species. Merton understood that each creature reveals the immanence of God. Each creature is God coming to us. Each day is an experience of Advent. Making straight the way of the Lord, building a highway in the desert is not for the purpose of going to God. We can't "get to God" for God is too great, too transcendent. God must come to us. God has and God does. God is continually revealing God's Self in the world around us. God's fullness is present in the person of Jesus, and in God's overflowing love expressed in each creature.[3] God is not *Deus absconditus* but *Deus intimus,* a God who, Saint Augustine said, is more intimate to me than I am to myself, a God longing to be discovered as the very Ground of my being.

Evenings, too, were sacred times for Merton. Age-old monastic practice ended a day of work in the fields, punctuated by periods of prayer, with Compline, a short prayer, committing oneself to God's care during the night. The last hymn chanted by monks before the Grand Silence of the darkened monastery is the *Salve Regina,* an ancient petition to Mary,

A HEAVY SNOWFALL IN
THE WOODS NEAR DOM
FREDERIC'S LAKE
*Photo #*MF37-04

"As regards prayer—in the hermitage. To be snowed in is to
be reminded that this is a place apart, from which praise goes
up to God, and that my honor and responsibility are that
praise. This is my joy, my only 'importance.' For it *is* impor-
tant! To be chosen for this! And then the realization that the
Spirit is given to me, the veil is removed from my heart, that
I reflect 'with open face' the glory of Christ." (*Learning to Love,*
January 23, 1966)

"mother of mercy, our life, our sweetness and our hope." Merton looked forward to this evening ritual, for it brought the monastery business—the noisy machinery and the cheese making—to rest, at least for a time, and offered him a longer period of uninterrupted solitude. Silence and darkness soon descended on the whole valley, broken only by the scamper of late-night creatures, the occasional call of the whippoorwill, and the *basso profundo* of the courting bullfrog. On his walks back and forth to the hermitage, Merton loved to gaze at the planets and the evening star; sometimes he caught sight of a passing jet, like a "small rapid jewel traveling north" across the face of the moon (DWL 180). Other nights he would continue his contemplation outside, observing the mist in the low bottoms, the glow of lights off to the east, and the sound of the occasional passing car on the highway beyond the monastery gate. All was settling down to rest. As Merton wrote in *Hagia Sophia:* "The shadows fall. The stars appear. The birds begin to sleep. Night embraces the silent half of the earth" (CP 370).

Despite the suffering that raw winter temperatures could bring to monks living in an unheated monastery, Merton especially loved the winter, with its crispness and "pale bright-blue sky" that reminded him of England. He loved to watch the snowy hills hanging "like white clouds in the sky," the crunch of the snow as he followed the paths in the woods, and the "whiskers of frost on the dead cornstalks and on the creosoted gateposts" (DWL 168). He welcomed the cracking of the ice forming and breaking up in the rain barrel near his hermitage. As he wrote in "Early Blizzard," he loved a raging snowstorm when he could be "knee deep in silence" (CP 650). Even when confined to the monastery with a cold or the flu, Merton spent long hours gazing out of a window and marveling at the way light became an artist of the snow.

At Saint Bonaventure's in Olean, Merton had loved to recite the Breviary while walking in the "untrodden drifts along the wood's edge, towards the river." There the canopy of trees formed a "noiseless, rudimentary church" between Merton and the sky. And there he came to realize his love for his beautiful, adopted American countryside. "What miles of silences God has made in you for contemplation! If only people realized what all your mountains and forests are really for!" (SSM 309–10). Now, at Gethsemani, it was the snow-filled Kentucky woods that most attracted Merton. He knew firsthand how the "snow falling from trees [made] the woods sound as though they were full of people walking through the bushes" (DWL 76). In his poem "Two States of Prayer" Merton likened the snow-buried woods to the great "penitential peace" of "Christmas mercies" (CP 150). He often witnessed how "snowflakes meet on the pages of the Breviary" (OSM 60). At other times the harsh storm winds "grumbling" in

PINE TREES UNDER A BLANKET OF FRESH SNOW, NEAR CROSS KNOB *Photo #*MF38-09

"Yet I need very much this silence and this snow. Here alone can I find my way because here alone the way is right in front of my face and it is God's way for me— there is really no other." (*Turning Toward the World,* January 28, 1963)

SMALL SAPLINGS ENVELOPED BY DEEP, SPARKLING SNOW *Photo #MF38-04*

"Lovely blue and mauve shadows on the snow, and the indescribably delicate color of the sunlit patches of snow. All the life of color is in the snow and the sky." (*A Search for Solitude,* February 17, 1958)

THE ROAD TO CROSS KNOB COVERED IN SNOW *Photo #*MF38-06

"I climbed the Lake Knob. Wonderful woods. Slid down the steep hillside in the snow. Tore my pants on barbed wire. Came back through the vast fields and drifts of snow. Peace!" (*A Vow of Conversation*, January 1, 1964)

A SUMMER-MORNING
VIEW OF THE
MONASTERY FROM
THE ROAD TO THE
HERMITAGE
Photo #MF18-07

"Go, roads, to the
four quarters of our
quiet distance."
("The Evening of the
Visitation," *Collected
Poems*, 43)

"The path of creek gravel leads into the shadows and beyond them to the
monastery, out of sight, down the hill, across fields and a road and a dirty stream."

(*Turning Toward the World,* May 16, 1961)

the trees near the hermitage were "like friendly beasts" (DWL 66). Seeing the woods and fields full of snow gave him a deepening sense of this "wild land, my home" (SS 145–46). On his predawn walks to and from the hermitage, he had no trouble finding his way with the snow on the ground, especially when the moon "poured down silence over the woods" (DWL 93). Above, Merton was surrounded by the "hard brightness of stars" (DWL 172).

Some evenings Merton had fire-watch duty. He loved to sit in the monastery tower gazing at the "enormous darkness of the clear sky full of stars," which seemed to be "falling down upon the world like snow. They fall and fall and never arrive" (SS 12). In the cold winter months he loved to identify the constellations, stars, and planets keeping him company: Venus and Mars, Orion, Aquarius, Vega, Spica, Arcturus, Sirius, "the great icy M of Cassiopeia's chair, and . . . the red winking eye of Aldebaran" (SS 345). Almost nightly the Kentucky sky, untainted by the glow of city lights, revealed a multitude of stars in a deep expanse of space. At such times Merton was engulfed by memories of "the lostness and wonder" of his first days in the monastery, when he had left everything to live for God alone. His imagination relived "the stars, the cold, the smell of night, the wonder . . . and above all the melody" of the Advent chant. He remembered how the December solitude was "inhabited and pervaded by cold and mystery and woods and Latin liturgy." Now spending days and some nights in the woods as a hermit, Merton was brought "face to face with the loneliness and poverty of the cold hills and the Kentucky winter—incomparable, and the reality of [his] own life!" (DWL 160, 172).

Lying in bed one night at the hermitage, cold and alone in the all-pervasive darkness of the winter woods, Merton realized he was happy, deeply happy. His feeling was not happiness as an object to be studied. "It simply was. And I was that." The next morning, coming down to the monastery for Mass under a canopy of stars, Merton was overwhelmed with the meaning of his life and the care of God for him. He understood in the depths of his being how the mercy of God had loved him into being and guided him to this place (DWL 177–78).

Merton's fiftieth birthday, which was spent in the hermitage, further deepened his sense of vocation. Not only did he experience the fierce cold of the night air; he also "realized momentarily what solitude really means: When the ropes are cast off and the skiff is no longer tied to land, but heads out to sea without ties, without restraints! Not the sea of passion, on the contrary, the sea of purity and love that is without care" (DWL 200).

Whether his surroundings were crisp and clear, as Kentucky winters could be; sweltering and still, as the humid summers could become; over-

SYCAMORES ACROSS THE ROAD FROM THE MONASTERY *Photo #*MF11-03

"Yesterday, Feast of Saint Francis Xavier, it was so warm that I could sit out there in one of the alcoves behind the church, holding the *Usages* in my hand and squinting out through the fine rain at the branches of the whitewashed sycamores." (*The Sign of Jonas,* December 6, 1948)

cast and threatening, with intermittent rain; or redolent with the promise of spring blossoms, Merton was alert to the uniqueness of each day, often noting the weather in his journal. "Another of the beautiful, cool days we have been having all year. We did not work this afternoon" (ES 86). "It is grey outside, and snow falls lightly" (ES 34). "A wonderful sky all day beginning with the abstract expressionist Jackson Pollock dawn—scores of streaks and tiny blue-grey clouds flung like blotches all over it" (DWL 138). "Clouds running across the face of the waning moon. Distant flashes of lightning. I know what it is: a 'warm front'" (DWL 158).

Merton was aware of the pervasiveness of weather. It is the air we breathe and the breeze that cools us, the snow we shovel, the raindrops we dodge or lift our face to receive, and the sunshine we bask in. Changeable as it is, weather announces itself daily—and in some areas, according to local lore, every fifteen minutes. Merton's multiple references to the light, configuration of clouds over the distant knobs, and the frequent Kentucky rains seem commonplace, a chaotic collection of scientific and poetic observations. His weather reports appear at the beginnings of journal entries; sometimes they are sandwiched between two longer discussions of events in the monastery or notations about his reading; occasionally they provide the finale for his musings that day. The comment is usually straightforward: "All day it has been dark and hot and wet. Sweat rolls down your back in church" (ES 217). "Hot, murky afternoon" (TTW 229).

Such puzzling annotations may remind us of how parents often begin phone conversations or letters. They also resemble the calendars or daybooks kept by Midwestern farmers, which record weather data that shape their field activities for the day and provide, over time, a log of climatic patterns and community responses to them. They are reminiscent of the written reflections of modern desert dwellers who recommend overcoming the threat of monotony by noting the "episodic landscape."[4] Such weather reports also remind one of the even older practice (which Merton knew about) of marking seasonal changes, such as the notations kept by medieval monks like Pseudo-Bede, who cited February 11 or 12 as the "day when the birds begin to sing" (WN #14, June 1964).

Whatever their motivation and resemblance, such weather data seemed to create a context of normalcy for Merton. In some unconscious way he was painting the whole canvas of his day, so that his particular experience appeared integrated into the scene.[5] Weather reports were the context for Merton's poetic eye, feeding his imagination and offering fodder for language. At the same time they were the points of departure for his subsequent imaginative and philosophical wanderings. Commenting on a succession of dark winter days, Merton admitted that the weather had

A VIEW LOOKING WEST FROM MONKS ROAD TOWARD TENT KNOB *Photo #*MF 34-03

"It is five years since I came to the monastery. It is the same kind of day, overcast. But now it is raining. I wish I knew how to begin to be grateful to God and to Our Lady for bringing me here." (*Entering the Silence,* December 10, 1946)

been dismal, yet he drew from it a spiritual lesson: "I love the strength of our woods, in this bleak weather. And it *is* bleak weather. Yet there is a warmth in it like the presence of God in aridity of spirit, when He comes closer to us than in consolation" (SJ 263).

For one so aware of the changes in light, temperature, and season, Merton must have been aware of the influence of weather on his life early in his monastic experience. Yet he did not explicitly mention its significance until five years before his death, when he confided the following in a journal entry:

> Our mentioning of the weather . . . [is] perhaps not idle. Perhaps we have a deep and legitimate need to know in our entire being what the day is like, to *see* it and *feel* it, to know how the sky is grey, paler in the south, with patches of blue in the southwest, with snow on the ground, the thermometer at 18, and cold wind making your ears ache. I have a real need to know these things because I myself am part of the weather and part of the climate and part of the place, and a day in which I have not shared truly in all this is no day at all. It is certainly part of my life of prayer (TTW 299–300).

"I myself am part of the weather and part of the climate and part of the place. . . . It is certainly part of my life of prayer." A haunting admission. In *The Seven Storey Mountain* Merton wrote that when he entered the monastery, he believed his physical journeying was over. At Gethsemani, then, he was free to explore the knobs and valleys of the monastery property, note the mist or rain, sun, or breeze, and their connection to the weather of his heart. Weather was never solely the backdrop for his living. It was an integral part of Merton's inner and outer life. It affected and effected his internal landscape. As he wrote in "O Sweet Irrational Worship"—a poem about transformation in prayer—"I am earth, earth" (CP 344). One could say that Merton's frequent weather reports were not just a guide to how to *act* but a guide to how to *be*. In short, *habitat*—the weather and, indeed, the whole landscape—became interlaced with *habitus*—Merton's way of living.[6]

Because of the Kentucky climate and the companionship it provided in the woods, rain merited frequent—almost weekly—comment. "It rains very slightly and a song sparrow sings in the rain" (SS 183). "Sounds of rain in the night—I lay in bed appalled by the weight of water falling upon the earth, it seemed, in a solid mass. Wonder what happened to the crops" (SS 213). "Continual rain, and the rain seems to make the red oaks grow redder still" (SS 261). "The thunder cracks and beats. Rain comes flooding down from the roof eaves and the grass looks twice as green as before" (TTW

108). "We have been praying for rain . . . at Mass. So this morning around the offertory a steady rain began . . . and it has gone on pouring down ever since, floods of it in a constant and uninterrupted and very vocal cascade all day long. The land is full of its rumor and all our fields have rivers running through them" (ES 325). "It has been raining steadily for almost 36 hours. This morning toward the end of my meditation the rain was pouring down on the roof of the hermitage with great force and the woods resounded with tons of water falling out of the sky. It was great!" (LL 3). In his poetry, too, Merton delighted in the rain, "louder than a cyclone," whose "free refreshment" created an island for him to converse with God (CP 197).

Rain and its "meaningful meaninglessness" is featured in one of Merton's most widely anthologized essays, "Rain and the Rhinoceros" (1966). Alone in his hermitage in the woods during a long evening of steady rain, Merton was aware of the rain's music and its all-encompassing vigor. Rain made itself heard on the porch, the roof, the trees. Rain became both the impetus for his writing and the controlling image of his meditation on the distinction between uselessness and functionality. Attuned to the "climate of the woods," Merton declared the rain to be a veritable "festival" and himself the chief celebrant of "its gratuity and its meaninglessness" (RU 9–10).

When you are alone in a rainstorm deep in the woods, away from city lights and partying neighbors, it is easy to distinguish the orchestrated music of the rain: the rhythmic tattoo on the roof; the higher pitched teeming on mossy bark and thick green foliage that increases in pitch and tempo as the rain intensifies; and the pizzicato of dripping trees as the thrumming slowly abates. Merton loved the melodies the rain created and committed himself to listening to "all that speech pouring down." In contrast to his experience of communion with the rain's "enormous virginal myth, a whole world of meaning, of secrecy, of silence, of rumor," Merton noted how rain in the city is most often considered an inconvenience. He lamented that because of human inattentiveness, most of us cannot see that we are "walking on stars and water" (RU 10, 12).

Merton's ability to artfully comment on the weather and times of day, to create fresh imagery to describe the ponds, trees, and deer transformed him from merely looking with his eyes to seeing with his heart. Celebrating the diversity of the natural glory around him enabled Merton to attend to the divine spark in all of creation, the same spark that was revealing itself more and more profoundly in his own soulscape. Merton's outward glance at the lights, colors, and shapes around him evoked increasingly frequent and deeper inward glances that often resulted in spiritual insights. Over time these insights fed Merton's hunger for greater solitude and lured him more deeply into the transforming power of contemplation.

HEAVY RAIN COVERS A ROAD LEADING INTO THE WOODS *Photo #*MF34-10

"Heavy and steady rain with high winds for two days on end—and much rain before it. . . .
Wonderful black skies over the woods, great strong expectancy of spring in all the wet, black
trees." (*Dancing in the Water of Life,* March 10, 1964)

A TREE REFLECTED IN A PUDDLE FORMED BY HEAVY RAIN *Photo #*MF 52–12

"Now caught in many spells

Willing prisoner of trees and rain."

("Merlin and the Deer," *Collected Poems*, 737)

CHAPTER 4

Becoming One with the Sky through Prayer

MERTON'S INTERACTION with the knobs, valleys, fields, and woods around the monastery and, later, his solitude in the hermitage constantly revealed to him the contours of his inner geography. Sometimes Merton's observations of the weather, wind, or woods flowed naturally into formal prayer or contemplative reflection; sometimes his formal prayer and meditation burst into praise of the sacramental goodness of life around him; and sometimes his experience of outer and inner landscapes merged in an intense experience of communion.

Merton was adept at finding God in nature, knowing that "All nature is meant to make us think of paradise. Woods, fields, valleys, hills, the rivers and the sea, the clouds traveling across the sky, light and darkness, sun and stars, remind us that the world was first created as a paradise for the first Adam. . . . All God's creatures invite us to forget our vain cares and enter into our own hearts, which God Himself has made to be His paradise and our own" (NMII 115). Watching the warbler migration, for example, was for Merton an experience of "religious awe," of feeling "close to God" (SS 124). Cataloging the dazzling light, the blue sky, the clouds, the silence of the afternoon, and the vegetation of Saint Malachy's Field led Merton to reflect on the continuity of grace in his life and the necessity of placing all his confidence in God. It was then that the specific beauty of that day became a "beautiful, transfigured moment of love for God" (DWL 9). At other times, while watching "the stars and the sky paling out behind Rohan's knob," Merton was prompted to ask God to "lock me in Your will, imprison me in Your Love and Your Wisdom, and draw me to Yourself" (ES 101). One evening at the hermitage Merton saw the "great spear" of a comet flashing across the night sky. Its brilliant white tail was counterbalanced by the cry of a stag beyond the hedge, the sound of the monastery

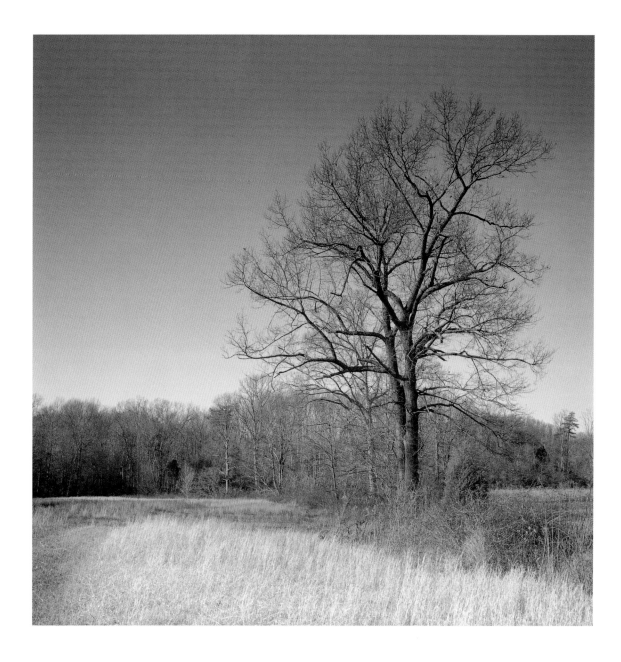

BARE TREES AT THE EDGE OF SAINT MALACHY'S FIELD *Photo #*MF01-04

"A good, fruitful, though slightly anguished meditation in the wood by St. Malachy's field. The paradise smell under the pines." (*A Vow of Conversation,* January 23, 1964)

bell in the distance, and the intrusive drone of a military plane overhead. Caught up in this ecstatic moment of joy, Merton was moved to recite Psalm 18, celebrating how the heavens continually announce "the glory of God and the firmament proclaims his handiwork" (DWL 312–13).

Experiences such as these were moments of *theoria physike* (natural contemplation), discovering, as Saint Maximus had long ago explained, the "silent revelation" of God in the visible world, knowing that there was a synergy between God and nature.[1] Merton was well aware of this synergy. In *New Seeds of Contemplation* he affirmed: "[I]t is God's love that warms me in the sun and God's love that sends the cold rain. . . . It is God's love that speaks to me in the birds and streams" (16–17). Merton loved Hugo Rahner's statement that "man is the incarnate dialogue with God," adding his own spin on Rahner's insight: "But God speaks his word also in *Creation*—hence for all men there is a possibility of dialogue with Him in & through their own being and in their relation to the world in which He has placed them" (WN #32, January 23, 1968). For Merton that dialogue was possible in every tree, flower, cloud, and breeze he encountered.

One day, seeing a vase of carnations in the novitiate chapel, Merton's attention was arrested. He was entranced by the beauty of the sunlight falling on the scene. The contrast of the sunlight and the darkness of the "fresh crinkled flower" might have triggered a flashback to the chiaroscuro world of his youth. But the existential power of the moment also evoked a prayerful response. "This flower, this light, this moment, this silence = *Dominus est* [The Lord is here], eternity!" Merton believed the moment was worth celebrating because each item—flower, light, silence, and even himself—was itself. A monastic simplicity might have cautioned against putting the carnations on the altar, yet Merton valued the better, more pleasing simplicity that could enjoy the flowers in their vase precisely because they revealed and glorified a reality lurking beneath the lights, colors, and silence (SS 164–65).

The interlocking impulse of nature and prayer also proved fruitful in reverse order. Whether he was meditating, deep in wordless contemplation, or reading Scripture, Merton's formal prayer often blossomed into a tribute to the sacramental character of nature. In the woods, thinking "of nothing except God," Merton's finely honed sense of God's immanence made him intensely aware of the "sun and the clouds and the blue sky and the thin cedar trees." His prayer became more inclusive, noticing how all these creatures—the longer shadows, a solitary singing bird, oak leaves in the breeze, and the sound of a car in the distance—comprised the actuality of "God's afternoon." All contributed to this "sacramental moment of time" that not only delighted Merton but also confirmed his commitment to

BRIGHT MORNING SUNLIGHT ILLUMINATES A VASE
OF RED AND WHITE CARNATIONS *Photo #c35-05-02*

solitude. "The more I am in it, the more I love it. One day it will possess me entirely" (SS 16).

Merton understood that nature, because of its innate goodness, contributed in its own way to the cosmic praise of the Creator. All creation was sacramental and therefore worthy of his notice. Barn animals, flowering trees, fish, and water joined in the communion of saints, praising God by being their unique selves.

> Their inscape is their sanctity. It is the imprint of His wisdom and His reality in them. The special clumsy beauty of this particular colt on this April day in this field under these clouds is a holiness consecrated to God by His own creative wisdom and it declares the glory of God. The pale flowers of the dogwood outside this window are saints. . . . This leaf has its own texture and its own pattern of veins and its own holy shape, and the bass and trout hiding in the deep pools of the river are canonized by their beauty and their strength. The lakes hidden among the hills are saints, and the sea too is a saint who praises God without interruption in her majestic dance (NS 30).

Even with his eyes cast down on a page of Scripture or theological treatise, or engaged in the reflective practice of *lectio divina,* Merton's thoughts flowered into a celebration of the divine spark in nature. The exuberance of the moment buoyed Merton's spirit and enticed him into the dance of life. At those times Merton felt "so renewed that all nature seems renewed around me and with me. The sky seems to be a pure, a cooler blue, the trees a deeper green, light is sharper on the outlines of the forest and the hills and the whole world is charged with the glory of God and I feel fire and music in the earth under my feet" (SJ 215–16).

So strong was Merton's conviction that nature continually reveals God that he counseled his novices to be alert to God everywhere. "Life is simple," he told them. "We are living in a world that is absolutely transparent, and God is shining through it all the time. This is not just a fable or a nice story, it is true. . . . God manifests Himself everywhere, in everything—in people and in things and in nature and in events. . . . You cannot be without God. It's impossible, it's just simply impossible."[2]

Merton's love of nature and his commitment to contemplation often caused his inner and outer landscapes to merge. In these moments Merton enjoyed an intense experience of integration and wholeness. "My Zen," he wrote, "is in the slow swinging tops of sixteen pine trees. One long thin pole of a tree fifty feet high swings in a wider arc than all the others and

BR. ALFRED McCARTNEY CARRYING THE NIGHT WATCHMAN'S CLOCK

Photo #35-40-06

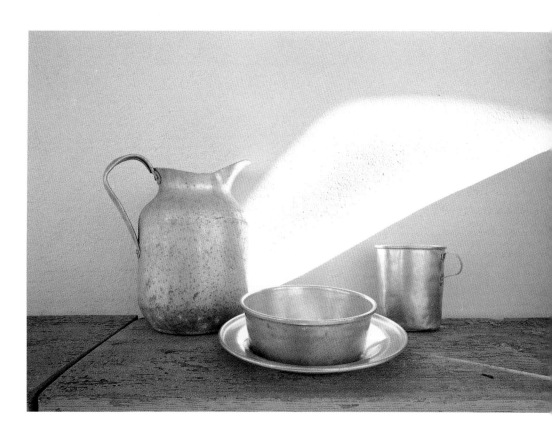

OLD DINNERWARE ONCE USED BY THE MONKS *Photo #35-44-05*

"Waiting for the monks to come,

I see the red cheeses, and bowls

All smile with milk in ranks upon their tables."

("The Reader," *Collected Poems*, 202)

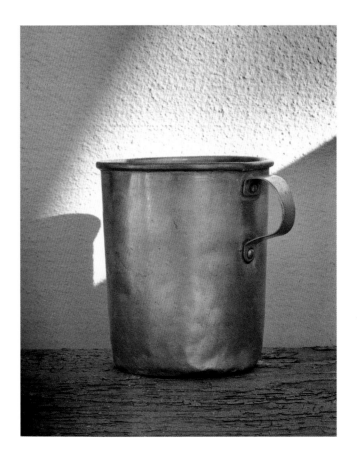

A METAL CUP FROM THE REMAINS OF OLD DINNERWARE
Photo #35-44-10

swings even when they are still. . . . My watch lies among oak leaves. My tee shirt hangs on the barbed wire fence, and the wind sings in the bare wood" (SS 232).

One day, while he was reading in the woodshed, a small wren hopped onto Merton's shoulder, then onto the corner of his book, before flying away. After the delight of such an intimate contact with nature, Merton mused on various kinds of knowing. He preferred a "primordial familiarity" with nature that was more intimate than the knowledge gained from scientific experiments in a laboratory. Bird knowledge was what he was after. "This is the reality I need, the vestige of God in His creatures. And the Light of God in my own soul. . . . The wren either hops on your shoulder or doesn't" (SS 189–90). Merton was struck once again by how his particular vocation was to be vulnerable to each moment: to see and to see again, to use his imagination in a religious act of deriving meaning from experience. Merton was committed to expanding his vision, embracing simple events, and allowing their cosmic significance to take root in his heart. For Merton this commitment became an ever-deepening habit of awareness "where everything I touch is turned into prayer: where the sky is my prayer, the birds are my prayer, the wind in the trees is my prayer, for God is all in all" (TS 94).

One of Merton's favorite ways of talking about his landscape of prayer was through nature metaphors. Sprinkling his description with color imagery and comparing it to ocean depths, Merton revealed a dimension of his own prayer experience. If he closed his eyes in prayer—amid the elms, the blue hills, and the red clay—Merton saw blue and purple fish swim before his eyes in his sea of contemplation. But this was not all he saw. There were additional depths to his vision and to his prayer. At the first level the surface was troubled; ripples easily disturbed his equilibrium. This was the arena of activity, resolutions, planning, and interaction with his students. At the second level he experienced darkness through which blue, purple, green, and gray fish swam. Nevertheless, here was peace and natural prayer where words drowned in the dark, comfortable silence and rest. This was the level Merton desired to write about, which the Desert Fathers knew required purity of heart and obedience. Going even deeper to the third level, Merton described himself as swimming in pure air—positive life—where starlight and moonlight were charged with anticipation and waiting, where God was both expected and received, present and gone. This, commented Merton, was "the holy cellar of my mortal existence, which opens into the sky. It is a strange awakening to find the sky inside you and beneath you and above you and all around you so that your spirit is one with the sky, and all is positive night" (ES 468).

FIREWOOD STACKED ON THE EAST SIDE OF THE HERMITAGE *Photo #*MF18-03

"A great deal of the wood I have for the fire is wet or not sufficiently seasoned to burn well—though finally this morning I got a pretty hot fire going with a big cedar log on top of it." (*Dancing in the Water of Life,* February 2, 1965)

Merton's experience of communion with all around and in him is lyrically portrayed in his account of his journey as the night watchman, making his rounds to assure the safety of the monastery. His famous "Fire Watch" description, written as a prose poem (July 4, 1952) and published as the epilogue to *The Sign of Jonas,* celebrates in story both the dynamism of a sacred place and Merton's emotional and spiritual vulnerability to an immanent God. Merton was dutiful in his role as night watchman. He was alert, looking for fire in the imposing wooden structure of the monastery, but he was also conscious of the living spirit of this place. He created word pictures of the dishes and silverware for postulants who ate in the hallways and of the desks for the scholastics in the crowded library. He tapped into the "geological strata" of the monastery (SJ 354). Stairwells murmured to Merton the events of his past, and walls babbled about stories from years gone by. Having at last climbed to the tower, Merton was now exposed to the night wind. Sensing the presence of a "huge chorus of living beings," he peered into the frozen distance of the stars. At the peak of his journey, both physically and spiritually, Merton was moved to profess his simple, personal credo: "There is no leaf that is not in Your care" (SJ 361). Overcome with awe at the power of creation and the presence of the Word-made-flesh within, Merton experienced in the dark night the immanence of Reality itself. Meeting God was no longer accomplished with words. Rather, the Word born in his soul begot a rich, new communion. No poetic imagery could adequately articulate this experience. Merton could only rhapsodize about "the emergence of life within life and of wisdom within wisdom. . . . The Father and I are One." He could only offer a list of paradoxes that confirmed the uniqueness of God's ways. At this exhilarating moment all that mattered was the profound experience of *"Mercy within mercy within mercy"* (SJ 362).

Merton knew from study and experience that the only authentic atmosphere for prayer was the solitude of the desert. He had even written an article entitled "The Climate of Monastic Prayer"—which was later published as *Contemplative Prayer*—focusing on a history of Benedictine spirituality and God's invitation to all Christians to explore their inner terrain in solitude. Merton believed that the mystery of God and the mystery of self were linked. Paradoxically, when we discover God, we do not know God as "the object of our scrutiny"; rather, we come to know "ourselves as utterly dependent on his saving and merciful knowledge of us." Just as the early Desert Fathers and Mothers moved to the edge of society in order to find their "authentic reality in God," so Merton sought greater solitude in the woods in order to penetrate beneath the mask of the false self advocated and valued by society. Here in silence he discovered his true self in God (CNP 113–14).

FIREWOOD ON THE FLOOR INSIDE THE HERMITAGE *Photo #*MF04-03

"In the afternoon, work takes up so much time, and there can be so much. Just keeping the place clean is already a big task. Then there is wood to be chopped, etc. The fire is voracious—but pleasant company." (*Dancing in the Water of Life,* January 30, 1965)

Merton's experience of finding God in the ground of his being was linked to a deepening awareness of and love for nature—humans and non-humans alike. In reality these impulses were not two distinct movements but one. Prayer of the heart is a "returning to the heart" where, in the "organic" unity of our day, we discover how loving others is the "condition for a vital and fruitful inner life" (TME 65). All is embraced in one act of loving awareness. After his first night in the hermitage, Merton described the intensity of his solitude as he recited Compline. He prayed "gently and slowly with a candle burning before the icon of Our Lady." In that great peace of the endless night, under twinkling stars many light-years away, Merton sensed the truth: "That this [is] the way things are supposed to be." A few hours later, while reciting Lauds "quietly, slowly, thoughtfully, sitting on the floor," he felt "very much alive, and real, and awake, surrounded by silence and penetrated by truth. Wonderful smell of pre-dawn woods and fields in the cold night!" (DWL 154).

Meditating in a field accompanied by fireflies was not "a manifestation of narcissistic regression." On the contrary, Merton knew that contemplation was a "complete awakening of identity and of rapport! It implies an awareness and acceptance of one's place in the whole, first the whole of creation, then the whole plan of Redemption" (DWL 250). As Merton wrote in *New Seeds of Contemplation,*

> [I]f we could let go of our own obsession with what we think is the meaning of it all, we might be able to hear His call and follow Him in His mysterious, cosmic dance. We do not have to go very far to catch echoes of that game, and of that dancing. When we are alone on a starlit night; when by chance we see the migrating birds in autumn descending on a grove of junipers to rest and eat; when we see children in a moment when they are really children; when we know love in our own hearts; or when, like the Japanese poet Bashō we hear an old frog land in a quiet pond with a solitary splash—at such times the awakening, the turning inside out of all values, the "newness," the emptiness and the purity of vision, that make themselves evident, provide a glimpse of the cosmic dance.... Yet the fact remains that we are invited to forget ourselves on purpose, cast our awful solemnity to the winds and join in the general dance (296–97).

While Merton could write about his innermost experience with vivid and elaborate imagery, he could also write about prayer with efficient precision and conviction. Contemplation is "simple openness to God at every

THE SCREEN DOOR AT THE HERMITAGE ENTRANCE *Photo #MF03-12*

DETAIL OF THE CONCRETE BLOCK WALL INSIDE THE HERMITAGE
Photo #MF 19-07

"There are enough shadows in the corners, and the stone fire-
place shows up well and the concrete blocks too—there is
enough roughness so that it looks like anything but a factory,
thank God. In fact the modulation provided by the latticework
blocks is really impressive!" (*Dancing in the Water of Life,* February
16, 1965)

A LIGHTED CANDLE ON THE FIREPLACE MANTEL OF THE HERMITAGE
*Photo #*MF19-08

"Though it had been quite cold for several days, I got enough sun into the place in the afternoon to dry it out and warm it up. Got up there about nightfall. Wonderful silence, saying compline gently and slowly with a candle burning before the icon of Our Lady. A deep sense of peace and truth. That this was the way things are supposed to be, that I was in my right mind for a change (around the community I am seldom in my right mind). Total absence of care and agitation." (*Dancing in the Water of Life,* October 13, 1964)

moment, and deep peace" (TMA 143). It is the sunflower whose awakened dark center is celebrated in "Song for Nobody" (CP 337). In short, contemplation is "life itself, fully awake, fully alive, fully aware that it is alive. ...It is spontaneous awe at the sacredness of life, of being" (NS 1).

It should probably not surprise us that Merton's need for increased solitude blossomed into a yearning to live permanently in the hermitage. After each short hospital stay for a series of shoulder, elbow, and back ailments, Merton longed to embrace again the silence of the woods. Deep within himself he knew that living in the wilderness was his vocation. Despite his periodic flirtation with the idea of joining the Carthusians, the Camaldolese, various Latin American foundations, and relocating to the American Southwest, Merton realized that Gethsemani was his home. The Holy One had whispered to him through nature, allowed the landscape to shape his consciousness, and at last intended to claim him. In the silence of the woods Mystery waited to dialogue with his heart. Merton could only respond "yes." As he wrote: "I belong to this parcel of land with rocky rills around it, with pine trees on it. These are the woods and fields that I have worked in, and walked in, and in which I have encountered the deepest mystery of my own life. And in a sense I never chose this place for myself, it was chosen for me" (CGB 234).

The wilderness was so intertwined with Merton's spirituality that when he was in the monastery, the evening croaking of the frogs kept him awake; at the hermitage, however, the frogs became an "extension of [his] own being" bringing comfort and a sense of inclusion (DWL 213). There he could live in ecological balance with the trees and "fifteen or twenty" species of birds in the woods around his hermitage. There he could savor the "mental ecology, too, a living balance of spirits in this corner of the woods" (DS 33–35). There was not only birdsong to be enjoyed but also the songs of poets and philosophers to be sung and responded to, voices representing both Western and Eastern, ancient and contemporary thought.

Merton offers us a tribute to the wilderness in *Day of a Stranger* (1965), an elegant and eloquent description of his life at the hermitage. In the woods Merton was "free not to be a number" (DS 31). With the woods as his home, he could live fully the Benedictine ideal of an integrated life: "What I wear is pants. What I do is live. How I pray is breathe" (DS 41). Through the hermitage window Merton witnessed the first glimmer of light that signaled the dawn. He saluted the 2:15 A.M. "primordial lostness of night" that welcomed the light illuminating his icon of the Holy Virgin. In this sacred place he recited the psalms of Vigils and Lauds, which "grow up silently by themselves without effort like plants in this light which is favorable to them" (DS 43). Daily Merton was "alone at the resurrection of

A CRUCIFIX DESIGNED FOR MERTON BY ERNESTO CARDENAL HANGS
NEAR THE FIREPLACE IN THE HERMITAGE *Photo #*MF04-11

Day, in the blank silence when the sun appears" (DS 51). In such an atmosphere of solitude, he could assert his identity as hermit, one who had "decided to marry the silence of the forest" and take as his wife the "sweet dark warmth of the whole world." Here in the stillness Merton experienced the "virginal point of pure nothingness which is at the center of all other loves . . . the primordial paradise tree, the *axis mundi,* the cosmic axle, and the Cross" (DS 49).

Such a commitment to solitude, framed in these lush metaphors of fecundity, became for Merton a pivotal moment that, fourteen months later, may have influenced his decision to remain in the woods. Having fallen in love with a student nurse while in the hospital for back surgery in March 1966, Merton was torn between two loves: his passion for "M" and his passion for solitude. Yet Merton knew himself to be a "wild being." Ultimately he must remain alone. "Freedom, darling. That is what the woods mean to me. I am free, free, a wild being, and that is all that I ever can really be. . . . Darling, I am telling you: this life in the woods is IT. It is the only way. . . . All I say is that it is the life that has chosen itself for me" (LL 341–42).

Merton's poetic description of his life at the hermitage was more than a series of clever metaphors. In this Garden of Grace he was aware of the need to plow his soul-soil, water it with silence, and un-nest the evil hiding in the crannies of his heart: "After twenty-three years all the nests are well established. But in solitude and open air they are revealed and the wind blows on them and I know they must go!" (DWL 177).

Merton allowed the atmosphere around him—dawn, birds, trees, the smell of the air, the silence of the woods—to permeate his being. He allowed his prayer to blossom into an earth-based spirituality. In the woods, amid its diverse weather and hidden treasures, Merton discovered his intimate relationship with God and a heightened awareness of the interconnection of all creation. This awareness and love of exploration never waned. Even in his last months at the hermitage Merton was discovering new ponds and hillside vistas on the monastery property (OSM 66). During his trip to the California redwoods and Alaska, Merton continued to celebrate his sense of place as he read the calligraphy of snow and rock from the airplane window (OSM 182).

Monastic life can often be thought of as living on the margin, on the edge. The early Desert Fathers and Mothers sought the margins of society so that they might see more clearly and live more consciously the values of Christianity. They were not detaching themselves from things in order to find God but rather detaching themselves from their false self "in order to see and use all things in and for God." They knew, as did Merton, that there is "no evil in anything created by God, nor can anything of His

CRUCIFIX AND ICONS IN THE HERMITAGE CHAPEL *Photo #MF17-10*

become an obstacle to our union with Him" (NS 21). By living on the edge, they acquired a kind of bifocal or multifocal vision, intensely aware of the rugged landscape around them and just as intensely aware of their wild inner landscape, which presented similar challenges to surviving and flourishing.

Merton was consciously expanding his vision by living on the margin. He could see life and its richness from many perspectives. He was both inside the monastic community and apart from it in the hermitage; he was committed to silence and solitude, yet extended his compassion to the world by writing on controversial contemporary issues such as racism, war, nuclear power, technology, peace, and nonviolence; he was both bystander by choice and central participant in the dialogue of the sixties; he was a monk of the Western tradition yet able to contain within himself both East and West thanks to his study of Eastern spirituality—especially Zen; he was practical yet contemplative, clearing brush and fighting forest fires and sitting quietly in prayer in the woods; he was trained in *lectio divina* yet also adept at reading nature and experiencing God in the unfolding of grace, which we call Creation; he could write eloquently of the lyricism of nature yet embrace the daily, prosaic ritual of confronting the king snake curled up on the rafters of his outhouse ("Are you in there, you bastard?" [DS 53]).

Borrowing a term from ecology, one could say that Merton lived successfully on the "ecotone"—that margin or boundary between two distinct environments that shares some of the attributes of each. Living on the ecotone is always a risky situation. There is the possibility of new sources of nourishment for one venturing beyond the safe, familiar ground, yet also the danger of becoming a potential source of nourishment for "opportunists creeping in from the opposite side."[3] Although ecologists primarily refer to predators as opportunists, those serious about prayer know that God is also a kind of opportunist. If we permit ourselves to be vulnerable to God, we will be swallowed up in overwhelming and transforming grace. Merton committed himself to just such a vulnerability, allowing himself to be, in Jonathan Montaldo's words, "God's bait" (ES xiv). By living on the margin, Merton became both pursuer and pursued—a monk journeying home toward God and simultaneously waiting to be caught by the great Fisher-King. In a physical sense, Merton was lured into the woods so that, like Thoreau, he could learn to live deliberately and reflectively. In the spiritual sense of Hosea, Merton allowed himself to be lured into the wilderness so that God could possess his heart. By developing deeper and deeper prayer of the heart, Merton discovered—as did the early desert dwellers—the flowering cactus of compassion.

CHAIRS ON THE FRONT PORCH AT THE HERMITAGE *Photo #*MF23-06

"'Solitude' becomes for me less and less of a specialty, and simply 'life' itself. I do not seek to 'be a solitary' or anything else, for 'being anything' is a distraction. It is enough to be, in an ordinary human mode." (*Dancing in the Water of Life,* June 18, 1965)

CHAPTER 5

Discovering Compassion
in the Wilderness

ONCE MERTON DISCOVERED the depths of contemplation and allowed
his awareness of the world around him to mingle with his desire for and
experience of God, his sense of compassion and justice blossomed into new
fruitfulness. His twenty-seven years in the monastery had not shut him off
from human society; rather, Merton became even more alert to our imper-
fect world and the ways in which human society oppresses people and
misuses the natural environment. The period spanning the late 1950s and
early 1960s became Merton's "turning toward the world," during which he
spoke out eloquently and prophetically against ethnic and racial injustice,
war and the nuclear arms buildup, as well as the dangers of technology. His
call for peace and nonviolence became, in Merton's mind, not only a cry
for just relationships among human beings but also a subtle plea for
improved interaction with our planet. The signs of his growing sensitivity
to environmental responsibility increased in number and intensity in his
later journals. While exulting in the morning light drifting over the knob
adjacent to his hermitage, or gazing intently at the deer in the clearing,
Merton was also keenly aware of human arrogance, which dared to domi-
nate the earth and exploit its resources.

As early as December 1962, Merton was "shocked" when he came
across a publication notice of Rachel Carson's *Silent Spring*. Even before
reading this new, controversial, and seminal book on the dangers of DDT,
Merton knew in his heart how important it was to "worry about *both* birds
and people. We are in the world and part of it and we are destroying every-
thing because we are destroying ourselves, spiritually, morally and in every
way. It is all part of the same sickness, and it all hangs together. I want to
get this book. Why? Because this is a truth I regard as very significant and I
want to know more of it" (TTW 274–75).

GRASS WET WITH HEAVY DEW, LIT BY MORNING LIGHT, AT THE HERMITAGE
*Photo #*MF17-01

"It is a cool brilliant morning. The birds sing. The valley is full of sunlit mist. The tall fiery day lilies are opening to the June sun. I know I am where I belong."

(*Learning to Love,* June 22, 1966)

DOGWOOD BLOSSOMS NEAR THE STATUE GARDEN *Photo #35-14B-09*

"Mixture of heavenliness and anguish. Seeing 'heavenliness' suddenly for instance in the pure, pure, white of the mature dogwood blossoms against the dark evergreens in the cloudy garden." (*Dancing in the Water of Life,* April 23, 1964)

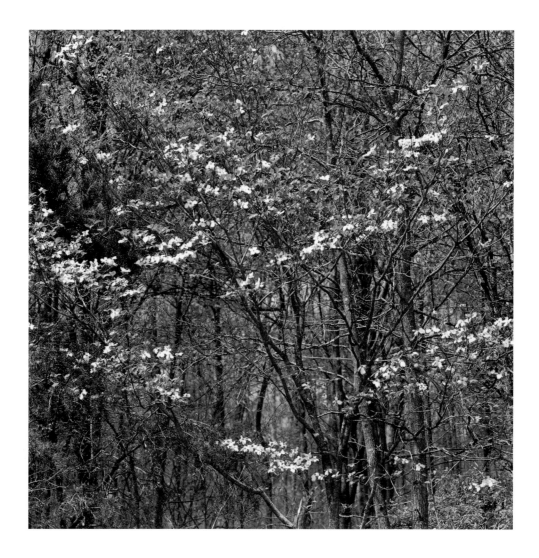

DOGWOOD TREES IN BLOOM AT THE EDGE OF THE WOODS NEAR SAINT EDMUND'S LAKE
*Photo #*MF14A-07

"Dogwood and redbud everywhere. Especially beautiful dogwoods among the dark pines in the grove by St. Edmund's field yesterday—a grey afternoon, with a few drops of rain now and again." (*Dancing in the Water of Life,* April 20, 1964)

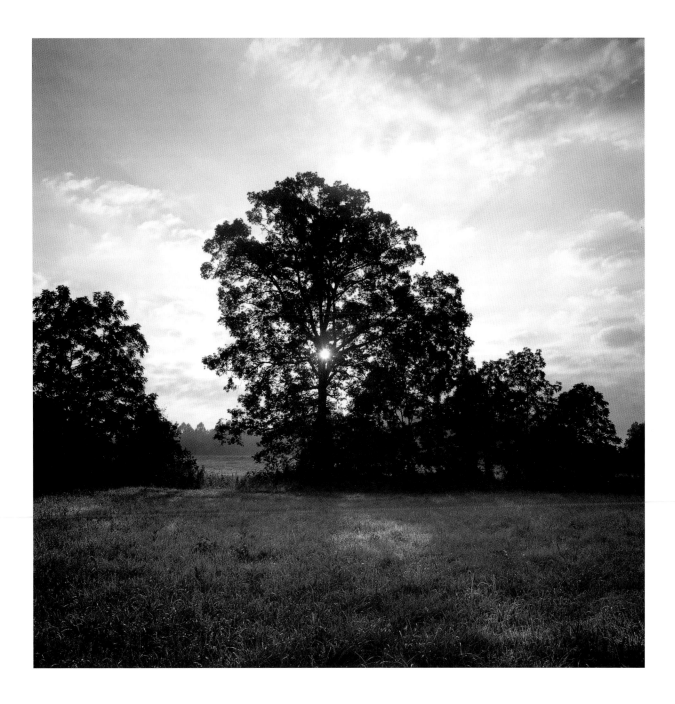

MORNING SUN SHINES THROUGH TREES NEAR THE STATUE GARDEN *Photo #*MF 57-11

"A spring morning alone in the woods. Sunrise: the enormous yolk of energy spreading and spreading as if to take over the entire sky. After that: the ceremonies of the birds feeding in the wet grass. The meadowlark, feeding and singing. Then the quiet, totally silent, dry, sun-drenched mid-morning of spring, under the climbing sun." (*Conjectures of a Guilty Bystander*, 268)

And "more of it" he did discover. After reading her engaging book, Merton wrote to Carson, complimenting her on her "fine, exact and persuasive book," which offered "evidence for the diagnosis of the ills of civilization," namely, our propensity for a "consistent pattern" of destruction that reveals a "dreadful hatred of life" (WF 70–71).

Having heard the voices of the landscapes in southern France, Rome, New York State, and now Kentucky, and having allowed their forms, sounds, and colors to shape his consciousness, Merton understood that in the cosmic dance there can be no wallflowers. All are expected to learn the steps. All are called upon to become part of the poetry-in-motion of this earthly paradisiacal garden. Merton was thus prompted to respond to a high school student: "[W]e Americans ought to love our land, our forests, our plains, and we ought to do everything we can to preserve it in its richness and beauty, by respect for our natural resources, for water, for land, for wild life [*sic*]. We need men and women of the rising generation to dedicate themselves to this" (RJ 330).

To an Italian graduate student inquiring about his values, Merton shared his belief in the sacramentality of nature: "God manifests himself in his creation, and everything that he has made speaks of him. . . . The world in itself can never be evil" (RJ 347–48). He responded to the news that no one would be allowed to live on Rum Island in the Hebrides "except those protecting the wildlife and trying to restore the original ecology" with the following comment: "This is wonderful!" (DWL 195).

In his later years Merton felt drawn to Celtic nature poetry, making copious entries in his reading notebooks about the influence of the wild Irish landscape on the hermits who had penned the delicate and soul-stirring lines. He loved the notion that "bird and hermit are joining in an act of worship; the very existence of nature was a song of praise in which he himself took part by entering into harmony with nature" (WN #14, June 1964). These ancient hermit bards, like his South American poet friends, were the dervishes, "mad with secret therapeutic love," who knew how to dance in the water of life (RU 160–61).

Merton, too, experienced that intimate bond between bird and man. Watching the myrtle warblers "playing and diving for insects in the low pine branches" filled him with a deepening sense of awe and a feeling of "total kinship with them as if they and I were of the same nature, and as if that nature were nothing but love. And what else but love keeps us all together in being?" (DWL 162).

Merton, however, wasn't always perfect in his interaction with nature. Sometimes he had to learn from his mistakes. He lamented his act of dumping "calcium chloride" on some anthills as a way of forcing the insects to

move elsewhere. Now, instead of the "beautiful whistling of titmice" near the hermitage, Merton discovered one bird "dead on the grass under the house. . . . What a miserable bundle of foolish idiots we are! We kill everything around us even when we think we love and respect nature and life. This sudden power to deal death all around us *simply by the way we live,* and in total 'innocence' and ignorance, is by far the most disturbing symptom of our time" (TTW 312).

Nevertheless, Merton's commitment to solitude, as well as his increased time at the hermitage, helped him see how the "fire in the grate," the sunrise with its "enormous yolk of energy spreading and spreading as if to take over the sky," the "ceremonies of the birds feeding in the dewy grass," and his own recitation of the psalms were all one. "How absolutely true, and how central a truth, that we are purely and simply *part of nature,* though we are the part which recognizes God" (TTW 312).

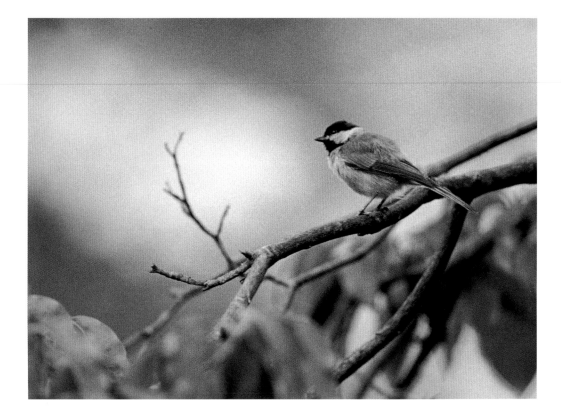

A CHICKADEE PERCHED ON A DOGWOOD BRANCH *Photo #35-65-18*

Sitting on the hermitage porch in the rainy woods, walking through the snow-covered paths to the monastery, or striding up the grassy knobs redolent with spring flowers, Merton learned to "live with the tempo of the sun and of the day, in harmony with what is around me" (DWL 146). He understood to the depths of his being the necessity of wilderness for contemplation: "In wilderness man purges himself of 'sediments of society' and becomes a 'new creature'" (WN #34, 1968). Moreover, Merton sensed a unique opportunity for monks to preserve the pristine quality of their landscapes. In a book review of two scriptural studies of desert wilderness, Merton was moved to comment: "If the monk is a man whose whole life is built around a deeply religious appreciation of his call to wilderness and paradise, and thereby to a special kind of kinship with God's creatures. . . . and if technological society is constantly encroaching upon and destroying the remaining 'wildernesses.' . . . [then monks] would seem to be destined by God, in our time, to be not only dwellers in the wilderness but also its protectors" (MJ 151). Merton even went so far as to add a footnote in which he mused that it "would be interesting to develop this idea" because hermits have a "natural opportunity" to act as forest rangers or fire guards in "our vast forests of North America"(MJ 184, n.2).

Like Wordsworth, whose delight in "the mighty world of eye and ear" permitted him to "see into the life of things" ("Tintern Abbey"), Merton continued to delight in learning more about nature. He spent more time in his later years reading about science and the environment. He delved into books by Loren Eisley; wrote himself reminders to read John Muir, founder of The Wilderness Society to which Merton belonged (WN #34, 1968); prowled the library in Louisville to read a "good article on Ecology in *Daedalus*" (DWL 274); and agreed to review a book by Roderick Nash entitled *Wilderness and the American Mind* (1967).

In what turned out to be one of his last published articles, "The Wild Places," Merton skillfully summarized American attitudes toward the wilderness over three and a half centuries.[1] Merton recalled the Puritans' sacred duty to subdue the wilderness, Thoreau's and the Transcendentalists' view of nature as a healing symbol, John Muir's commitment to preserve wilderness, Theodore Roosevelt's impulse to preserve hunting opportunities to support the cult of virility, and Aldo Leopold's principles for ethical land use. All of this must have been stimulating reading, setting Merton's love of nature aflame. He was particularly taken with Leopold's concept of an "ecological conscience" based on an "awareness of [our] true place as a dependent member of the biotic community" (PAJ 105–6). Leopold was utterly clear: "A thing is right when it tends to preserve the integrity, stability, and beauty of the biotic community. It is wrong when it tends other-

A PAIR OF MERTON'S BOOTS,
MERTON CENTER ARCHIVES,
BELLARMINE UNIVERSITY
Photo #MF41-06

MERTON'S WORK SHIRT, MERTON CENTER ARCHIVES,
BELLARMINE UNIVERSITY *Photo #35-40-26*

wise." What a moment of insight! Leopold's principle of the ecological conscience was the scientist's version of the heart knowledge Merton shared with the ancients. His principle was the articulated truth of the divine spark within all of us that the mystic experiences in an ineffable way. It was a contemporary translation of Wordsworth's song about "meadow, grove, and stream . . . Apparelled in celestial light" ("Intimations of Immortality").

Merton was ecstatic. This was the secret the landscape had long been whispering to his heart. This was how Merton was trying to live in the hermitage. Moreover, Merton knew that developing an ecological conscience would necessarily help develop a "peace-making conscience." When we arrive at decisions based on the intrinsic harmony of all life forms, we ourselves must possess not only a high degree of inner peace and harmony but also a commitment to reverencing all creation. When we have an intense awareness of our place in creation, we nourish authentic humility— *humus*—recognition that we are clay of the earth as well as stardust. What an awesome challenge and privilege, and what a worthy legacy to leave the twenty-first century.

Tuesday, December 10, 1968, dawned at Gethsemani cold and gray with an expected high of only 42 degrees. Nationally, President-elect Nixon was putting his cabinet together in preparation for the January 20th inauguration. Lyndon B. Johnson continued to hope that the Paris peace talks would yield a breakthrough in the 42 days before his administration dropped into the dustbin of history. There was hope for agreed mutual troop reductions, but it was also reported that the four-party talks could not manage to agree on the shape of the negotiating table—rectangular, as the U.S. insisted, or square, as the Communists demanded. Prospects for ending the war quickly were not promising, and hardly anyone believed the daily body-count boded a winning cause. A local newspaper reported that the number of Americans killed had just exceeded 30,000. In a brief story the paper also reported that Protestant theologian Karl Barth had died at age eighty-five. *Dr. Zhivago* and *The Boston Strangler* were at the first-run theaters, while *Night of the Living Dead* was a big hit with the local drive-in crowd. The countdown to Christmas was in full swing, and sports news centered on football. Joe Namath had shaved his Fu Manchu mustache in order to receive a reported $10,000 more in endorsement money, and Heisman Trophy winner O.J. Simpson was going to lead the South Squad running backs at the Hula Bowl in January.

In the monastery the brothers were engaged in their daily tasks of farm work and making cheese. They were also looking forward to the return of their own Father Louis, who had persuaded the new abbot, Dom Flavian Burns, to let him visit the Far East. Merton had left Bardstown on

September 11, stopping first at the monastery of Christ in the Desert in New Mexico and then Alaska, always on the lookout for a possible site for a hermitage that would afford him greater solitude. He had flown out of San Francisco on October 15 and was expected back at Gethsemani sometime in mid January. In India he had met with the exiled Tibetan Dalai Lama and set aside a few days of retreat at the Mim Tea Estate, within sight of awesome Mount Kanchenjunga. In Ceylon, at Polonnaruwa, he had viewed the enormous and strikingly beautiful Buddhas, a transcendent experience of "inner clearness, clarity, as if exploding from the rocks themselves" (AJ 233–35). Then Merton had traveled to Thailand for his scheduled talk to Benedictine and Cistercian monastic superiors. His pilgrimage to Asia was not only to share with his brother and sister religious the fruits of his Western monasticism but also to steep himself in the beauties of the Eastern tradition—"to drink from ancient sources of monastic vision and experience" (AJ 313).

Merton was staying in a small bungalow located on the outskirts of Bangkok in a compound owned by the Red Cross. He was looking forward to a day of meetings with Asian abbots and abbesses to discuss their different

MERTON'S COWL,
MERTON CENTER
ARCHIVES, BELLARMINE
UNIVERSITY
Photo #MF42-04

THE CHURCH BELL TOWER VIEWED FROM THE MONKS'
CEMETERY *Photo #MF 51-10*

"See, the kind universe,

Wheeling in love about the abbey steeple,

Lights up your sleepy nursery with stars."

("The Trappist Cemetery—Gethsemani,"

Collected Poems, 116)

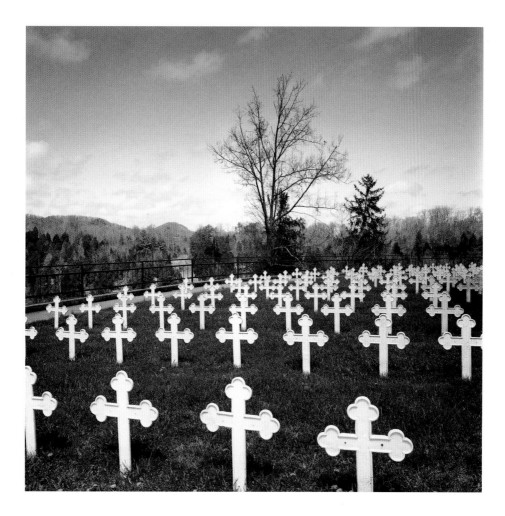

THE MONKS' CEMETERY AT GETHSEMANI *Photo #*MF51-03

"In the cemetery I looked up at the sky and thought of the great sea of graces that was flowing down on Gethsemani as her hundredth year is ending. All the crosses stood up and spoke to me for fair this time. It was as if the earth were shaking under my feet and as if the jubilant dead were just about to sit up and sing." (*Entering the Silence,* December 20, 1948)

monastic traditions. After giving his talk on "Marxism and Monastic Perspectives," Merton retired to his room for a siesta. At 4 P.M. that is where they found him—dead on the terrazzo floor. A standard electric fan lay across his body. The medical personnel could not say for sure whether Merton had suffered a heart attack while reaching for the fan or whether he had been electrocuted as a result of touching the faulty fan with wet hands. In any event, Thomas Merton, monk and writer, was dead at age fifty-three.

How terribly ironic that a monk who had taken a vow of stability should die a thousand miles from his hermitage. How painfully ironic that the body of this committed pacifist should return home on a military transport plane scheduled to ferry home body bags from the Vietnam War. How curiously ironic that his heart should stop beating on December 10, exactly twenty-seven years to the day since he had been accepted as a choir novice at Gethsemani. Yet how marvelously appropriate that in a light snowfall at dusk on December 17—his simple work shirt, boots, and cowl cast aside; his pilgrimage from Prades to England to New York to the Far East at an end—Thomas Merton should take his place beneath his beloved Kentucky clay in that long line of "jubilant dead . . . just about to sit up and sing" (ES 256).

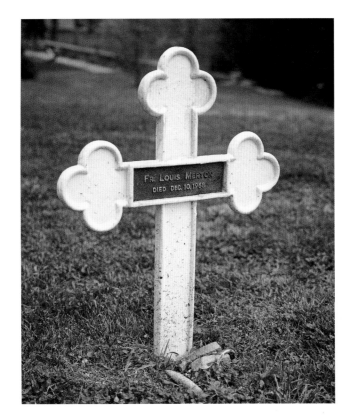

MERTON'S GRAVE AT THE ABBEY
OF OUR LADY OF GETHSEMANI
*Photo #*MF 50-12

NOTES

Introduction

1. Thomas Merton, "From Pilgrimage to Crusade," in his *Mystics and Zen Masters* (New York: Farrar, Straus & Giroux, 1967), 96.

2. Thomas Merton, *Run to the Mountain*, ed. Brother Patrick Hart (San Francisco: HarperSanFrancisco, 1995), 333.

3. Thomas Merton, *When Prophecy Still Had A Voice: The Letters of Thomas Merton & Robert Lax*, ed. Arthur W. Biddle (Lexington: The University Press of Kentucky, 2001), 84.

4. Thomas Merton, *The Monastic Journey*, ed. Brother Patrick Hart (Garden City, N.Y.: Image Books, 1978), 220.

5. Merton, *Run to the Mountain*, 333.

6. Thomas Merton, *Learning to Love*, ed. Christine M. Bochen (San Francisco: HarperSanFrancisco, 1997), 130–31

7. Thomas Merton, *The Seven Storey Mountain* (New York: Harcourt, Brace, 1948), 129–30.

8. Merton, "From Pilgrimage to Crusade," 91.

9. Thomas Merton, *Entering the Silence*, ed. Jonathan Montaldo (San Francisco: HarperSanFrancisco, 1996), 71.

10. Merton, "From Pilgrimage to Crusade," 97.

11. Thomas Merton, "Our Monastic Observances," unpublished manuscript in the archives of the Thomas Merton Center at Bellarmine University, Louisville, Kentucky. Emphasis in original unless otherwise indicated.

12. Thomas Merton, *Raids on the Unspeakable* (New York: New Directions, 1966), 9–10.

13. Merton, *Entering the Silence*, 486.

14. Merton, "Our Monastic Observances."

15. Thomas Merton, *Thoughts in Solitude* (New York: Farrar, Straus & Cudahy, 1958), 101.

16. Thomas Merton, *The Silent Life* (New York: Farrar, Straus & Cudahy, 1957), 38.

17. Merton, "From Pilgrimage to Crusade," 111.

18. Thomas Merton, *A Search for Solitude*, ed. Lawrence S. Cunningham (San Francisco: HarperSanFrancisco, 1996), 347.

19. Thomas Merton, "Elegy for the Monastery Barn," in *The Collected Poems of Thomas Merton* (New York: New Directions, 1977), 288–89.

20. Merton, *Entering the Silence*, 486–88.

21. Merton, "From Pilgrimage to Crusade," 97–98.

22. Thomas Merton, *The Hidden Ground of Love*, ed. William H. Shannon (New York: Farrar, Straus & Giroux, 1985), 115.

Chapter 2. Finding a Home in Nature

1. Bernard of Clairvaux, *The Letters of St. Bernard of Clairvaux,* trans. Bruno Scott James (Chicago: Henry Regnery, 1953), epistle #106.

2. Thomas Merton, *Gethsemani Magnificat: Centenary of Gethsemani Abbey* (Trappist, Ky.: Abbey of Gethsemani, 1949), np.

3. On this point see Belden Lane, *The Solace of Fierce Landscapes: Exploring Desert and Mountain Spirituality* (New York: Oxford University Press, 1998), 3–8; and Barry Lopez, "A Literature of Place," *Portland* (Summer 1997), 23–26.

4. See William H. Shannon, *Silent Lamp: The Thomas Merton Story* (New York: Crossroad, 1992), 62–63.

Chapter 3. Seeing Paradise with the Heart

1. Michael Mott, *The Seven Mountains of Thomas Merton* (Boston: Houghton Mifflin, 1984), 337.

2. Mott, *Seven Mountains,* 371.

3. William H. Shannon, "Homily," December 8, 2001, Sisters of St. Joseph Motherhouse, Rochester, N.Y.

4. Terry Tempest Williams, *Red: Passion and Patience in the Desert* (New York: Pantheon Books, 2001), 144.

5. On this point see Ross Labrie, *Thomas Merton and the Inclusive Imagination* (Columbia: University of Missouri Press, 2001), 244.

6. See Belden Lane, *Landscapes of the Sacred: Geography and Narrative in American Spirituality* (New York: Paulist Press, 1988), 103.

Chapter 4. Becoming One with the Sky through Prayer

1. On this point see *Merton and Hesychasm,* ed. Bernadetter Dieker and Jonathan Montaldo (Louisville, Ky.: Fons Vitae, 2003), 433.

2. Thomas Merton, *Thomas Merton: Essential Writings*, ed. Christine M. Bochen (Maryknoll, N.Y.: Orbis Books, 2000), 70.

3. John Elder, *Reading the Mountains of Home* (Cambridge, Mass.: Harvard University Press, 1998), 21.

Chapter 5. Discovering Compassion in the Wilderness

1. Originally published in 1968, this article has been reprinted in *Thomas Merton: Preview of the Asian Journey,* ed. Walter Capps (New York: Crossroad, 1989), 95–107.

HARRY L. HINKLE is a fine-art photographer in Lexington, Kentucky, specializing in traditional black and white exhibition prints. He is a former English teacher and public television publicist. Having exhibited in numerous solo and group shows, his work is included in private photo collections.

MONICA WEIS, a Sister of St. Joseph, is a professor of English at Nazareth College in Rochester, New York, where she teaches rhetoric, American literature, and American nature writers. She is a past vice president of the International Thomas Merton Society and has published frequently on Thomas Merton, composition theory, and various British and American writers.

BROTHER PATRICK HART was born in Green Bay, Wisconsin, in 1925, and did his undergraduate studies at the University of Notre Dame before entering the Abbey of Gethsemani in 1951. He was Thomas Merton's last secretary and since Merton's death has edited numerous books by and about him. He is currently the book review editor of *Cistercian Studies Quarterly* and was recently appointed general editor of a new Monastic Wisdom series of books by Cistercian Publications.

JONATHAN MONTALDO, a former director of the Thomas Merton Center at Bellarmine University in Louisville, Kentucky, edited Thomas Merton's *Entering the Silence; Dialogues with Silence: Prayers & Drawings; A Year with Thomas Merton: Daily Reflections from His Journals,* and *The Intimate Merton* with Brother Patrick Hart of Gethsemani. He served as the eighth president of the International Thomas Merton Society.

PERMISSIONS

The authors wish to thank the following publishers for permission to use excerpts from Thomas Merton's works:

"The Evening of the Visitation"
"The Messenger"
"The Regret"
"The Trappist Abbey—Matins"
By Thomas Merton, from *The Collected Poems of Thomas Merton,* copyright ©
 1944 by Our Lady of Gethsemani Monastery. Reprinted by permission
 of New Directions Publishing Corp and Pollinger Limited.

"A Letter to My Friends"
"A Whitsun Canticle"
"After the Night Office—Gethsemani Abbey"
"The Trappist Cemetery—Gethsemani"
"Trappists Working"
By Thomas Merton, from *The Collected Poems of Thomas Merton,* copyright ©
 1946 by New Directions Publishing Corporation. Reprinted by permis-
 sion of New Directions Publishing Corp and Pollinger Limited.

"Natural History"
"The Sowing of Meanings"
By Thomas Merton, from *The Collected Poems of Thomas Merton,* copyright ©
 1948 by New Directions Publishing Corporation. Reprinted by per-
 mission of New Directions Publishing Corp and Pollinger Limited.

"A Psalm"
"On a Day in August"
"Song"
"The Reader"
By Thomas Merton, from *The Collected Poems of Thomas Merton,* copyright ©
 1949 by Our Lady of Gethsemani Monastery. Reprinted by permission
 of New Directions Publishing Corp and Pollinger Limited.